MOMENTS IN MARIN HISTORY
Familiar Tales and Untold Stories

Scott Fletcher

Scott Fletcher

AMERICA
THROUGH TIME®
ADDING COLOR TO AMERICAN HISTORY

In memory of my father, Jerry Jerome Fletcher,
for passing on to me his love of history and the many stories
and precious memorabilia of our family's ancestry.

America Through Time is an imprint of Fonthill Media LLC
www.through-time.com
office@through-time.com

Published by Arcadia Publishing by arrangement with Fonthill Media LLC
For all general information, please contact Arcadia Publishing:
Telephone: 843-853-2070
Fax: 843-853-0044
E-mail: sales@arcadiapublishing.com
For customer service and orders:
Toll-Free 1-888-313-2665

www.arcadiapublishing.com

First published 2022

Copyright © Scott Fletcher 2022

ISBN 978-1-63499-405-7

Typeset in 10pt on 13pt Sabon
Printed and bound in England

Acknowledgments

In preparing to publish *Moments in Marin History: Familiar Tales and Untold Stories*, I have been supported and assisted by many friends, colleagues, local historians, and readers without whom this book would never have seen the light of day. First and foremost, I owe a huge debt of gratitude to the staff and board of directors at the Marin History Museum. The museum's board, and Ann Batman in particular, has entrusted me with the creation of the more than 130 Marin history articles published in the *Marin Independent Journal* newspaper that are the foundation of this book. The museum's board has also generously allowed me the use of the museum's photographs. Heather Powell, collections manager, has been my primary resource for accessing the image collection, patiently teaching me the use of the museum database software and cheerfully answering all my questions regardless of her own workload and deadlines. Lane Dooling, marketing, social media, and administrative coordinator, has provided me with invaluable assistance while working with the collection and has been my liaison with readers who have offered their thoughts on the published articles in the newspaper. I am particularly grateful to Carol Jensen of Fonthill Media who has helped me navigate the requirements and complexities of the publishing world while providing continuous support along with the occasional kick in the pants. I would also like to mention Kena Longabuagh of Fonthill, who has provided me with important documents and directions to resources that have helped me in this endeavor. I want to thank author and friend Laura Ackley for sharing with me her own experience in bringing a book to publication along with her optimistic support and words of wisdom. Sincere thanks are also due to those close friends who have so graciously given their time to read and review my work; they are former colleague, Ian Sethre; Zimbabwean poet, Ethel Irene Kabwato; and my niece, Olivia Buscho.

I am also indebted to many local historians and experts who have personally offered their advice and recommendations. Not all could be listed here, but I cannot fail to mention Dewey Livingston and Mike Moyle for their expertise in West Marin and dairy history, Dave Albee of the Dipsea Race Committee, Joe Breeze for his extensive knowledge of rail history in the county, Brian Sagar of the Fairfax Historical Society, Deb Rowland for her help with the Pacheco family history, Sean Nolan for information

on photographer, J. W. Carey, Matt Cerkel for his expertise on Marin Municipal Water District history, and John Bertland, digital librarian of the Presidio Trust. Last, but certainly not least, I want to thank my wife, Janet Fletcher, née Attaway, for providing timely counsel and unceasing moral support without which I could not have brought this book to print.

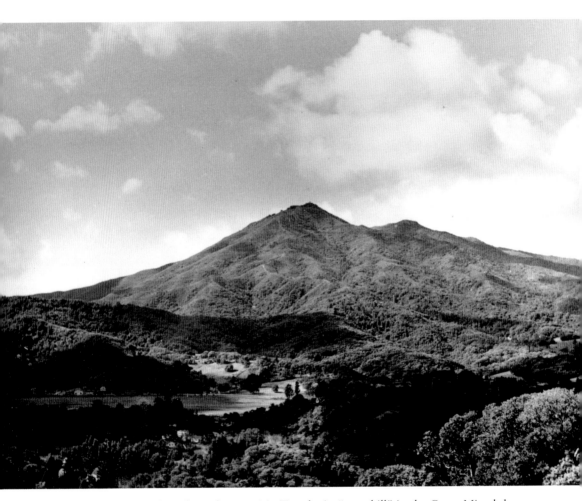

View of Mt. Tamalpais from the east. Mt. Tamalpais, "west hill" in the Coast Miwok language, has dominated Marin County life for thousands of years. Its centrally located, 2,600-foot peak and steep, forested terrain has been a major influence on indigenous and early European settlement patterns. These features have also helped determine the modern-day use of the land as not only a precious watershed for the county's water supply, but also its designation as an environmental preserve and recreational destination for San Francisco Bay Area hikers, bicyclists, campers, and tourists.

Contents

Maps

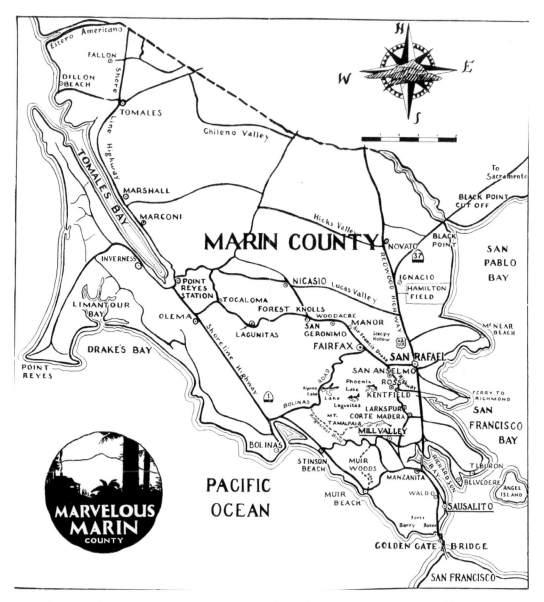

A map of Marin county published by "Marvelous Marin," a county-wide promotional organization of business and civic leaders.

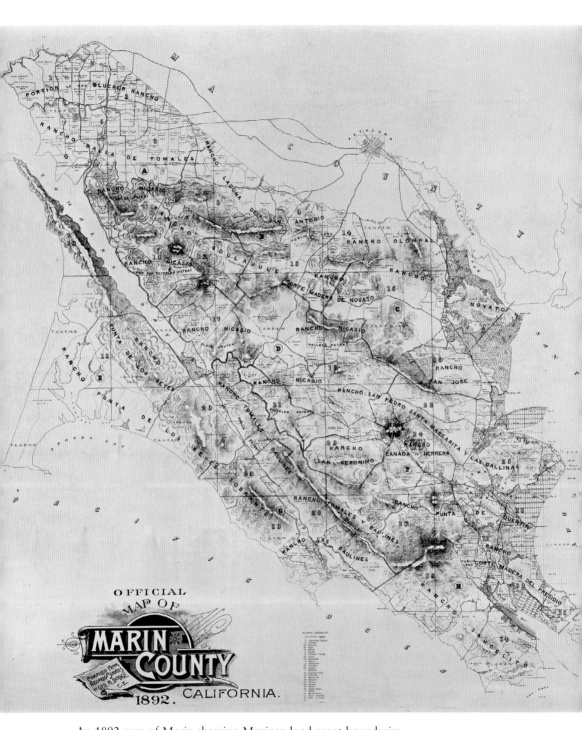

An 1892 map of Marin showing Mexican land grant boundaries.

Introduction

My journey writing *Moments in Marin History* began years ago when I plucked an obscure book off the shelf of my library at San Domenico School. It was Louise Arner Boyd's *The Fjord Region of East Greenland*. I was amazed to find such a treasure, written by an accomplished geographer, photographer, and arctic explorer of whom I had never heard. When I realized that Louise grew up in San Rafael, the town that my family and I moved to in 1985, I was astonished. That discovery led me to the Boyd Park Gatehouse in San Rafael and the offices of the Marin History Museum. On that first visit, I was asked that fateful question, "Would you like to volunteer?" The rest, as they say, is history.

As the title suggests, this book focuses on specific moments in time captured by often unknown photographers. It is not meant to be a complete and exhaustive history of Marin County. There are many well-researched, informative histories of the county that focus on a single town or city, a specific region, or a particular activity or mode of transportation. This book veers slightly from that design taking the reader on a visual tour that spans the length and breadth of the county, and whose narrative is determined by the images themselves. Each photograph was selected from Marin History Museum's considerable collection and tells a compelling personal story, or sheds light on the origins of Marin County's towns, cities, place names, and state and national parks. There are tales of great courage and determination, creativity and kindness, and hard work and perseverance. There are also stories of scandalous behavior, corruption and deceit, racial intolerance, and criminal acts and conduct.

In today's social and political climate, writing any history can be fraught with complexities and difficulties. Louise Arner Boyd's forgotten place in history exemplifies the fate that many women, people of color, and indigenous people have shared when histories are written. I have attempted to acknowledge that unfortunate legacy in connection with some of the people and locations featured in this book.

The Coast Miwok tribes, now part of the federally recognized Federated Indians of Graton Rancheria, were the stewards of the land we have come to call Marin (məˈrɪn) for thousands of years before Europeans came to the Pacific Coast. Their way of life

would not survive the waves of settlers that came to these shores searching to extend an empire, hoping for a new start in life, or scrambling for gold and riches. Suffering forced removal from their traditional lands and succumbing in great numbers to European diseases for which they had no immunity, the Miwok population decreased from 2,500 in 1810 to 250 in just forty years. Though our county has taken its name from a Miwok tribe member, Huicmuse, who was given the name Marino by the Spaniards in 1801, the stories of Marin's indigenous people lay dormant for nearly 200 years. Only recently have the few surviving ancestors of the original inhabitants begun to record and publish the traditions and history of their people.

Inside these pages, inspired by extant photographs, are tales of the Spanish and Mexican Land Grant families, the Californios, who lived and prospered before the Gold Rush, and the "Yankee" pioneers, settlers, and early residents who followed them after California became a state. Names like Richardson, Reed, Shafter, Black, Taylor, Marshall, and McNear reign supreme in the early decades of Marin County's more recent history. Those bearing such names established their own versions of empire in the timber, ranching, dairy, and shipping industries. But as the nineteenth century drew to a close, most of the large family ranches and tracts of land were sold off. Towns and cities began to grow, and the railroads came and changed everything. Marin County, once a fertile land for growing and raising food and timber for export to San Francisco, gradually transformed into a destination for hikers, campers, and vacationers. Weary city folk from around the bay began to seek refuge and sunny skies in new communities and in summer homes and cottages. The Great San Francisco Earthquake and Fire of 1906 sped up this process as thousands of San Franciscans escaped north and decided to make the county their home.

Over the last ten years, volunteering for the Marin History Museum has been, for me, a constant source of fascination with the history of Marin. I sometimes feel as if I am living two lives, one in this century and another in earlier times. As I travel around Marin, every town, old building, aging signpost, or street name holds a story that is waiting to be told. It is my hope that this book will be an enjoyable journey for readers to learn about some of the people, places, businesses, and events, both well-known and uncelebrated, that have contributed to the history of Marin County.

1

Captain William Richardson: Bay Area Pioneer and Sausalito Developer

William Richardson, a first mate on the American whaler *Orion*, sailed into San Francisco Bay in early 1822, jumped ship and settled near the Mexican Presidio in San Francisco. At that time, there were no streets or homes in what was known as Yerba Buena, just the Misión San Francisco de Asís, or Mission Dolores, and the military fort. The youthful Richardson realized the commercial potential of starting a business that supplied ships anchoring in the bay with supplies and goods for trade. He hired local Native Americans to help him transport grain and hides from around the bay to ships anchored at Yerba Buena and Whaler's Cove across the Golden Gate. From Whaler's Cove (eventually renamed Sausalito), he also supplied crews with fresh water from hillside springs and hardwood for spars and masts. Within a short time, Captain Richardson, as he was known, successfully petitioned the governor of California for Mexican citizenship and in 1825 married Maria Antonia Martinez, the daughter of the Presidio commander.

After traveling south to San Gabriel with his family for a couple of years, Richardson came back to San Francisco and was appointed captain of the port. He is credited with laying out the first streets in what would become the city of San Francisco and establishing the first civilian residence there for his wife and three children. As port captain, Richardson could direct incoming vessels to his thriving ship-supply business in Whaler's Cove that also included collecting duties and anchorage fees. In 1838, he was granted a large tract of land, over 19,000 acres, which ran from the northern shore of the Golden Gate, through the Marin Headlands to the Pacific Coast including what would become the town of Sausalito. He named it Rancho Saucelito ("ranch of the little willow grove") and began raising cattle to supply ships with beef and hides.

In its early days, the tiny port town was a wild and rambunctious community that catered to the needs of incoming ships and their sailing crews. In the 1840s, the United States Navy chose Whaler's Cove as the location for a drydock and set up a sawmill there to process the timber from the nearby hills. Richardson built his family's hacienda north of Whaler's Cove in what is now "New Town" Sausalito and expanded his operations to include a second waterworks and a deep-water pier for ships to transport

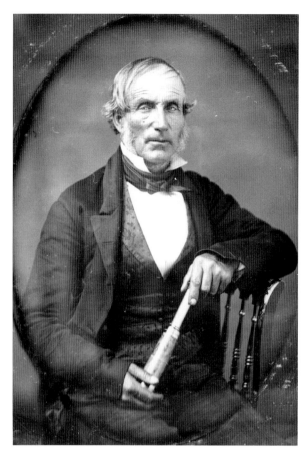

Portrait of early Bay Area settler, William Richardson.

products from his cattle ranch. However, Richardson was heavily in debt and was forced to sell a large portion of "Old Town" Whaler's Cove to Charles Tyler Botts, a San Francisco attorney who made his fortune after coming to California in 1848. Botts laid out grid-like streets and planned to sell individual lots to the ever-increasing population that followed the discovery of gold and California statehood. When the navy chose Mare Island near Vallejo as their West Coast shipyard, rather than Sausalito, the town fell on hard times. Richardson, who had borrowed heavily to run his ranch and shipping concerns, soon found himself unable to sustain his holdings. He ended up selling most of Rancho Saucelito to attorney Samuel Throckmorton except for a New Town portion deeded to his wife and the Old Town parcel he sold to Botts.

In 1856, Richardson lost three of his ships in quick succession and was embroiled in numerous lawsuits over his debts. In April of that year, suffering from rheumatism, the captain mysteriously died from mercury poisoning contained in tablets prescribed by his doctor. Though his family retained some of their New Town property, investment in the area was slow and Throckmorton and others eventually bought out the holdings of the Richardson family. Today, the bay between Sausalito and the Tiburon Peninsula bares Richardson's name in memory of the San Francisco Bay's first English-speaking resident.

2
Sunrise Over Angel Island:
An Isle of Hope and Despair

The first photograph below shows a glorious winter sunrise over Angel Island as seen from the hills above Sausalito. The tip of the Tiburon peninsula can be seen at the far left of the image. The island was a traditional hunting and fishing ground for the Coast Miwok tribes for many generations, when Juan Manual de Ayala of the Royal Spanish Navy sailed into San Francisco Bay and anchored on the large island in 1775. He would name the island Isla de Los Angeles, and the cove where his ship berthed now bears his name, Ayala Cove. Thirty years later, in 1814, the British sloop *HMS Raccoon* was repaired on the beach at Ayala Cove and the deep-water channel between the island and Tiburon became known as Raccoon Strait.

For much of the first half of the nineteenth century, Angel Island was used for cattle ranching, but in 1850, shortly after the Mexican American War and California's entry into the union, the island became a military preserve. During the Civil War, soldiers from nearby Fort Point constructed Camp Reynolds, the first permanent military installation on the island. In addition to providing troops to guard the entrance of the Bay from Confederate naval ships, the garrison also took part in campaigns against Native American tribes all over the western United States.

In 1891, the army changed the name of the post to Fort McDowell and a quarantine station was built to screen Asian immigrants entering the bay for the bubonic plague. A new, larger immigration station was constructed in the first decade of the twentieth century to detain Chinese and Asian immigrants seeking entry into the United States. At that time, there was widespread and virulent opposition to immigration from China. The Chinese Exclusion Act of 1882 prohibited immigrants who were, "both skilled and unskilled laborers and Chinese employed in mining" from entering the United States.[1] The immigration station became known as the Ellis Island of the West. According to the Angel Island Immigration Station Foundation's website, "Approximately 500,000 immigrants from 80 different countries were processed, detained, and/or interrogated at the site" before being granted immigration status or deported.[2] The detainees' internment lasted anywhere from a few weeks up to two years. The Chinese Exclusion Act was repealed in 1943 but it was not until the late 1950s and early 1960s that all

13

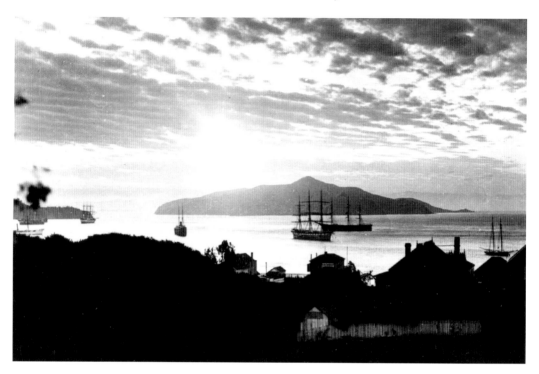

Sunrise over Angel Island, *c.* 1900. (*Photograph by Madison Devlin*)

Battery 'B' soldiers stationed on Angel Island, *c.* 1880.

racial and country-of-origin barriers were removed from U.S. law. Today, the Angel Island Immigration Station is a federally designated National Historic Landmark.

During both World War I and II, Fort McDowell served as a recruiting and training depot for men entering the Army and as a processing center for German, Japanese and Italian POWs. At the end of World War II, it was also used as a decommissioning station for U.S. soldiers coming home from the Pacific. The last military use of the island was short lived when, during the 1950s Cold War, the army built a Nike Missile base on the island that was operational for only eight years. In 1955, Ayala Cove was purchased by the California State Park System and by 1962 all military operations on the island ceased. The entire island was given over to the State of California where its sheltered harbor, historic buildings, and magnificent views attract tens of thousands of visitors each year.

3
The Reverend Reed's Sausalito "Flirtation Group"

By today's standards, the group of happy young couples below seems rather proper and sedate. However, in the latter part of the nineteenth century such groups where young, unmarried men and women would gather for socializing were thought by many to be indiscreet, if not downright improper. Pictured on the right with her eye firmly fixed on the young couples is the official chaperone, Mrs. Q. T. Marian. She is assisted in her duties by the slightly older couple in the rear, the Reverend Frederick Wilcox Reed and his lovely fiancé, Ellie Avery Reed. Other members in the group are May Merry, Blanche Merry, Etta Barrett, Sallie Maynard, Robert Maynard, Charles Barrett, Kate Stone, and Claude Hamilton. The photograph has a rare, whimsical spontaneity for the era that obviously reflects the spirit of the group.

Frederick and Ellie Reed were leading citizens in the early days of Sausalito and southern Marin, mostly through their efforts to bring the Episcopal faith to Marin County. In 1882, Reverend Reed became the first rector of the Sausalito Anglican parish and was instrumental in the planning and building of the lovely Christ Episcopal Church that still stands on a hillside overlooking the Sausalito harbor. Three years later he married Ellie Avery, the daughter of Francis Avery, a fellow parishioner and secretary of the Sausalito Land & Ferry Company. During this time, Reverend Reed also performed monthly Episcopal services in family homes for the growing community of Tiburon until the formation of St. Stephen's parish. The couple also traveled north by buggy to establish the first Sunday school class for the children of Mill Valley. It was their shared vision to create an Episcopal parish there, but tragedy took the Reverend Reed in 1890 at the youthful age of thirty-one. On a return trip from Europe, Reed died of tuberculosis in New York City, having suffered symptoms the previous two years.

Ellie continued teaching the Sunday school class in Mill Valley and arranged for services to be performed in the "redwood-encircled spot" where the present Church of Our Savior is located.[1] In 1892, Ellie married attorney and Sausalito developer Henry C. Campbell, a partner in the influential Tamalpais Land & Water Company. As a memorial to her late husband, Rev. Reed, Ellie provided all the funding for the construction of Mill Valley's Church of Our Savior on land donated by Campbell's firm. Frederick and Ellie were not only tireless leaders in the faith communities of southern Marin, but the image above also conveys their warmth and affection for each other and the young men and women of their parish.

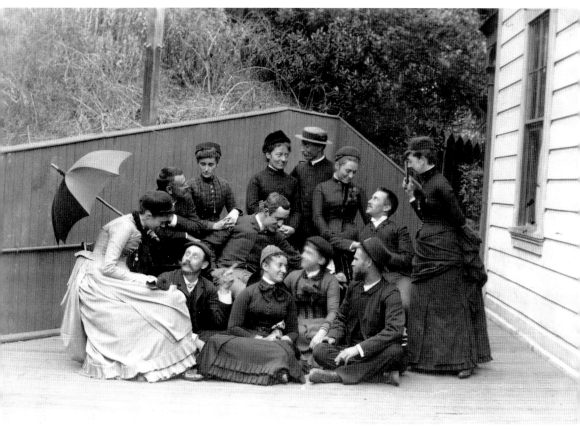

Group portrait of the Reverend Frederick and Ellie Reed's Sausalito Flirtation Group, 1885.

4

All Aboard in Mill Valley!

The first photograph below was taken more than 100 years ago, but for most Marin County residents it is instantly recognizable as downtown Mill Valley. There are scores of passengers queuing up for the train with a few late arrivals sprinting across the tracks. The redwoods in the center of the photograph still stand today separating the Depot Bookstore & Café parking lot from Miller Avenue. In the mid-1870s, the North Pacific Coast Railroad (NPC) laid narrow-gauge tracks from Sausalito to the junction north at San Anselmo, then to points west with a branch line to San Rafael. Within a couple of years, trains were running all the way to Duncan Mills in Sonoma County to carry north-coast timber and dairy products back to San Francisco via a ferry terminal in Sausalito. Passenger service to Cazadero in Sonoma County was added in 1886.

Before the downtown Mill Valley depot was built in 1889, the closest stations were a junction stop near today's Tamalpais High School called Almonte and another further north along the line that was named Blithedale. At that time, the town and its post office were renamed Eastland. Joseph Eastland, once president of the NPC, headed a group of investors operating as the Tamalpais Land & Water Company, a property development firm with extensive holdings in southern Marin. The NPC extended a branch line from the Almonte station to downtown and began planning the development of the town that would carry his name until 1904 when it was changed back to Mill Valley. During those early decades, visitors from around the Bay were also flocking to Eastland/Mill Valley to ride the Mill Valley and Mount Tamalpais Scenic Railway to the top of the Mt. Tamalpais. Nicknamed "The Crookedest Railroad in the World", its official name was changed to the Mt. Tamalpais & Muir Woods Railroad when the company laid tracks through to the pristine redwood groves of Muir Woods.

Both companies used the downtown Mill Valley station and passengers could switch lines easily and quickly when traveling to the mountain or home to San Francisco. In 1902, the NPC was sold and became the North Shore Railroad (NSR). Within a year the NSR converted the old narrow-gauge lines to standard-gauge and added an electric "third rail" design (seen in the photograph) for service from Sausalito to Fairfax and through to San Rafael. In 1907, the railroad was reorganized in a Santa Fe/Southern

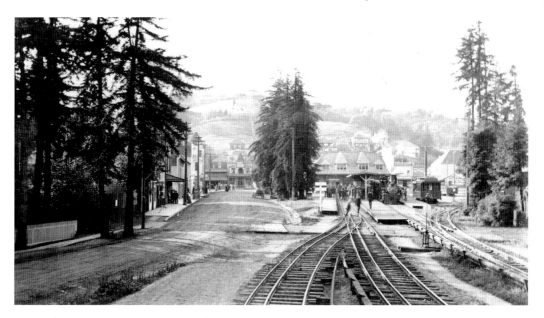

Above: Passengers waiting to board the North Shore Railroad train at Mill Valley's downtown station, *c.* 1910.

Below: Mt. Tamalpais Scenic Railway Depot in downtown Mill Valley, 1900.

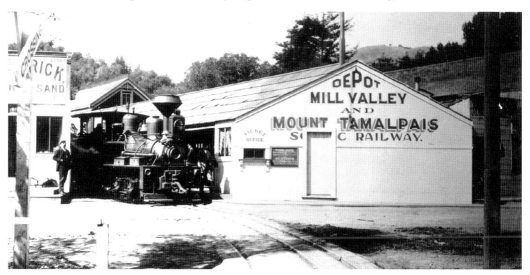

Pacific partnership and renamed the Northwestern Pacific Railroad. The original downtown station was demolished and replaced in 1929 by the mission-revival building that still stands on the site today. Less than fifteen years later, as automobiles and buses became the preferred mode of travel, commuter rail service throughout Marin was abandoned bringing an end to the county's heyday of train travel.

5
Holly Oaks Villa & Hotel:
The Crown Jewel of Sausalito

The Holly Oaks villa, built in 1887 by California pioneer fruit packer and shipping agent, George W. Meade (known as the Raisin King), was the crown jewel of Sausalito homes and hotels for many decades. It was celebrated for its ornate Victorian architecture, exquisite interior furnishings and unparalleled views of the San Francisco Bay and nearby Angel Island and Yerba Buena (then called Goat Island). In its early days, Sausalito had a slightly scandalous reputation as a rugged, untamed fishing village inhabited by mostly English and Portuguese fisherman and wealthy yachting enthusiasts looking to escape the foggy, urban environs of San Francisco. The Meade family brought a certain air of respectability to the growing town and local newspapers like the *Sausalito News* and *San Francisco Call* frequently reported on the many visitors and occasional luminaries who came to stay at Holly Oaks.

The Meade family's ownership of Holly Oaks did not last long as they put the house up for rent in 1890 just before embarking on a long European Tour. Meade eventually moved to Redlands, California where he became an influential land developer, expanded his business interests and became a city leader. Within a few years Holly Oaks was sold and converted into a luxury hotel and guest house and renamed the "Hollyoaks". For a brief time, a Mrs. M. A. Farar ran the hotel, but it was Mrs. Sawyer, a Civil War widow who had relocated to California, that managed the guest house for many years. A 1909 *Sacramento Bee* advertisement boasted of the Hollyoaks that it featured an 'Enchanting view of Bay and Mountain from every window. Unsurpassed table, first class in every respect. Bathing, good fishing, boating. Half-hour's ferry ride from San Francisco. Headquarters of S.F. Yacht Club and anchorage of U.S. Revenue Cutters'.[1]

Its reputation for fine food, luxury accommodations, and stunning views made it the only Sausalito Hotel to be mentioned in the 1909 Baedeker's Guide to the United States. Hollyoaks also catered to the residents of Sausalito hosting many weddings, galas, garden parties, and holiday gatherings, accounts of which appeared in the local newspapers.

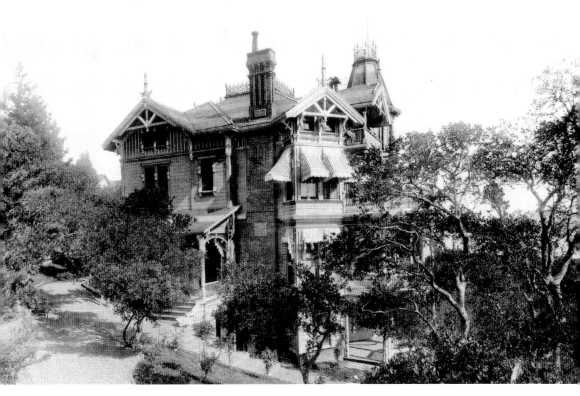

Sausalito's Hollyoaks Hotel printed on fine silk fabric, *c.* 1890.

 The hotel changed hands several times during the second decade of the twentieth century and at the height of the Great Depression the hotel was shuttered, and the furnishings and property put up for sale. In a last, rather ignominious *Sausalito News* item in 1939, an advertisement read, "FREE FIREWOOD: Wrecking Hotel Hollyoaks. 20 truck loads. Help yourself. 8 to 5."[2]

6
Belvedere Cove and Island: A Haven for the Well-to-Do

The photograph below of Belvedere Cove, taken from the shore of Belvedere Island, was originally named Stillwater Bay. It separates Belvedere Island, from present-day Corinthian Island and the Tiburon mainland seen in the distance. Belvedere Island was called El Potrero de la Punta del Tiburon ("The Pasture of Shark Point") by the Mexican officials stationed across the bay at San Francisco's Presidio.[1] It was later renamed Still Island, then Kashow's Island, Peninsula Island and finally Belvedere. The two islands were part of the 8,000-acre Mexican land grant of Rancho Corte Madera del Presidio ("The Ranch of Cut Wood for the Presidio") that was given to John Reed in 1834. Reed, an Irish immigrant, gained Mexican citizenship, married Hilaria Sanchez, the daughter of the San Francisco Presidio commandant, and built one of the earliest homes in Marin. The Reed's established the first sawmill in the county to supply the Presidio with much needed lumber. They also raised cattle and owned a brickyard and quarry.

Early settlers on Belvedere Island were fisherman Israel Kashow in 1855 and Nicolas Bichard in 1865. Kashow raised both sheep and cattle and established a profitable cod fishery on the island employing Chinese workers to cure and can hundreds of tons of fish each year. Bichard supplied Kashow with cod from the Alaska Banks and was also involved in boat salvaging. Disputes over boundaries and ownership of the Reed land culminated in attorney, James Bolton, winning title to the islands in 1868 after which the U.S. Army built a military reservation on the island. However, Kashow refused to leave for many years until another attorney, Thomas Valentine, won a case in federal court in which he succeeded in wrestling away most of the original land grant. In 1886, the Corinthian Yacht Club built its first clubhouse on what would soon be named Corinthian Island. The club used the famed "China Cabin" that was salvaged from the paddle steamboat *China* by Bichard years earlier and had it moved to Beach Road.

In 1890, Valentine formed the Belvedere Land Company and hired San Francisco City Engineer, M. M. O'Shaughnessy, to design the terraced hillsides and winding streets that surrounded the newly renamed Belvedere Island. Many of the original homes and mansions on the island, mostly summer residences for wealthy San Franciscans, were designed by famed architects Willis Polk and Julia Morgan. The town of Belvedere was

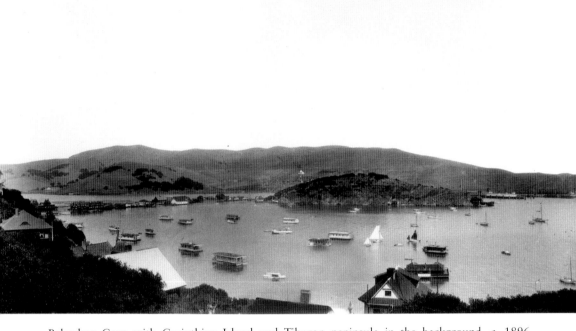

Belvedere Cove with Corinthian Island and Tiburon peninsula in the background, *c.* 1896. (*Photograph by J. W. Carey*)

incorporated in 1896 and by 1900 there were fifty homes and a luxurious fifty-room hotel on the island. Beach Road, seen in the photograph extending out into the cove, connects Corinthian Island in the distance to Belvedere Island in the foreground. Along Beach Road there was a post office, grocery store, telephone exchange, beauty shop, laundry, boatyard, plumber's shop, blacksmith's shop and even a jail. After the 1906 San Francisco Earthquake and Fire, many families moved permanently to their summer homes on Belvedere or onto the spacious floating arks in the cove. Also visible in the image background is Old Saint Hilary's Church high up on the hillside overlooking Corinthian Island. On the extreme right, can be seen a portion of the busy Tiburon ferry docks and railyards that connected San Francisco ferries to northern California timber, ranching and farming communities. Belvedere, once home to a cod fishery and military reservation is now one of the wealthiest communities in California and the United States.

7

Tiburon's Life as
a Bustling Port City

The busy Tiburon port and railroad depot pictured below stands in stark contrast to the scenic town and tourist destination we know today. Tiburon, Spanish for shark, received its name from Juan Manuel de Ayala y Aranza, an officer on the first European ship, the *San Carlos*, to sail into San Francisco Bay in 1775. Inhabited by Coast Miwok for generations, it was not until the late 1820s that early European settler and Marin pioneer John Thomas Reed first settled in southern Marin, operating a ferry service between nearby Sausalito and San Francisco. In 1834, Reed petitioned the governor and received the land grant, Rancho Corte Madera del Presidio that included the Tiburon Peninsula, most of Mill Valley and parts of Corte Madera and Larkspur. Early industries on the peninsula included numerous dairy ranches, a brickyard that supplied material for the construction of Fort Point, two companies that manufactured explosive powder, a codfish processing plant and a marine salvaging operation.

The port grew rapidly when Colonel Peter Donahue, a wealthy San Francisco industrialist, brought the southern terminus of his San Francisco and North Pacific Railroad (SF&NP) to Tiburon in 1884. The railroad's former port, connecting Northern California to ferries serving San Francisco, was on the distant Petaluma Creek in Sonoma County. With the move south, Tiburon became a bustling port city connecting the markets, ranches and timber industries in the north to San Francisco and the greater Bay Area. The SF&NP railroad yards were able to not only repair and service trains, but to fabricate passenger and freight cars and locomotives. As the port facilities grew, the Tiburon shipyards also began construction on several of the largest San Francisco ferries.

In 1904, the navy purchased a portion of the Tiburon peninsula from Reed's heirs and built the first coaling station on the Pacific Coast. The installation, with its deep-water wharf, provided fuel for the navy's coal-powered ships including Teddy Roosevelt's Great White Fleet visit to San Francisco in 1908. The coaling station was in operation for more than twenty-five years until the navy converted its coal-powered fleet to oil in 1931. For a few years, the site was used as a nautical training school before moving to Vallejo and becoming the California Maritime Academy. During the four years of construction on the Golden Gate Bridge (1933–1937), the company of John Roebling

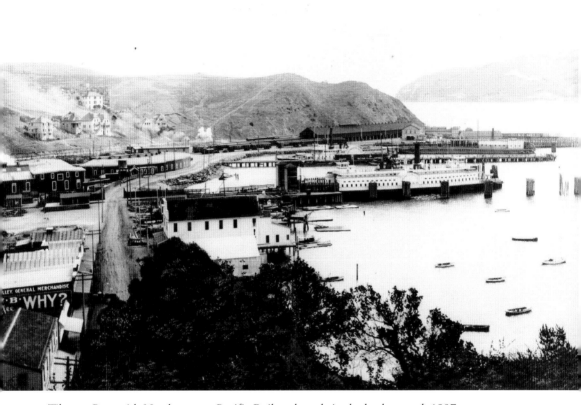

Tiburon Port with Northwestern Pacific Railroad yards in the background, 1907.

and Sons, used the facility to spin the suspension cables for the bridge. With the onset of World War II, the U.S. Navy took back the installation and manufactured over 100,000 tons of submarine and torpedo netting at the site, including the nearly seven miles that stretched from Sausalito to the San Francisco Marina.

With the passing of rail service in the 1960s, and the former Navy Net Depot converted first to a marine laboratory and then the Tiburon Center for Environmental Studies, the industrial nature of Tiburon began to change. Local planners began the decades-long process of setting aside much of the peninsula as open space and rebuilding the town into an upscale residential community and a prosperous tourist destination.

8

World War II, Marinship, and the Birth of Marin City

In early 1942, as great numbers of Allied shipping were being sunk by the combined Japanese and German fleets, the U.S. Maritime Commission asked the Bechtel Co. of San Francisco if they could build a West Coast shipyard to help in the war effort. Bechtel believed that Richardson Bay near Sausalito, with its railroad lines and potential deep-water access to San Francisco Bay, would be the perfect spot for a shipyard. Company representatives went to Washington, D.C., and ten minutes into their presentation, the government approved Bechtel's plan. Within weeks, residents of a hilly neighborhood just north of downtown Sausalito, called Pine Hill, were unceremoniously evicted, and the hill was excavated and dumped into the bay for fill. To accomplish the rapid construction of the shipyard, 2,000 workers labored in shifts around the clock driving 26,000 pilings into the bay to create the shipyards and the new warehouses and fabrication workshops. A 300-foot wide by 1.5-mile channel was dredged in Richardson Bay to allow vessels to reach the deep-water portion of San Francisco Bay.

To house the huge influx of workers coming to build the ships, the construction of what is now Marin City in the Leaside Valley just north of the shipyards was completed within three weeks, giving birth to an entirely new town. There were more than 2,700 housing units that ranged from dormitories for single men that rented for $5.50/month, one-room apartments that went for $29.00/month up to a six-room house for families that rented for $44.00/month. The community also had a public library, drug and department stores, cafes, a barber and beauty shop, childcare centers, a health facility, and a community center. Thousands of workers from around the country migrated west to work in Bay Area shipyards that also included facilities in Richmond, West Oakland, and Hunters Point in San Francisco.

Many of the new workers were women, African Americans, and Asian Americans hoping to secure one of the many high-paying jobs at the shipyard. According to the Marin City Community Development Agency website, Marin City was "the country's first integrated federal housing project" with 6,500 people, including over 1,000 school-aged children.[1] The demographic make-up during the war was 85 percent White, 10 percent African American, and 5 percent Asian. There were incidents of

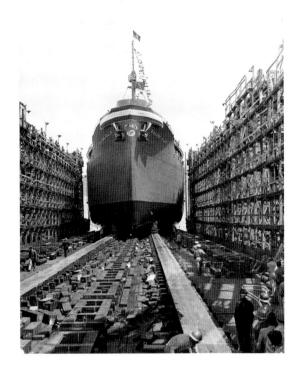

Right: Marinship workers ready to launch the Paloma Hills tanker, April 1945.

Below: Recently constructed Marinship housing in Marin City, 1942.

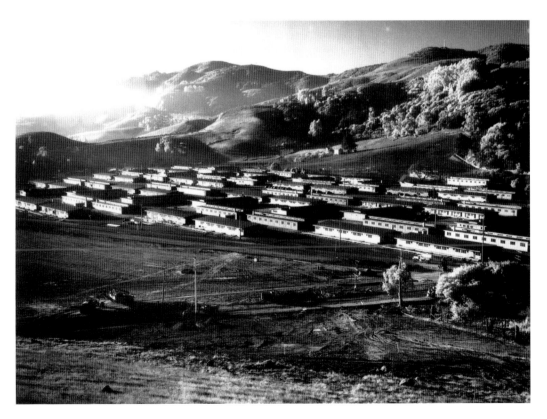

racial discrimination towards minority workers, not only from locally owned businesses that refused service, but also from the union that represented shipyard workers. The Brotherhood of Boilermakers, Iron Shipbuilders, and Helpers of America gave African American members auxiliary status which resulted in fewer union benefits and the denial of voting privileges. Eventually these inequities were reversed in the landmark Supreme Court decision, *James vs. Marinship*, argued by none other than future Supreme Court Justice Thurgood Marshall. In that decision, the Supreme Court found:

> If a closed-shop contract was in place and that workers must be union members to work, then unions cannot be closed to any members based on their race or any other arbitrary conditions. Discriminatory practices involved in this case are, moreover, contrary to the public policy of the United States and this state. The United States Constitution has long prohibited governmental action discriminating against persons because of race or color.[2]

Despite these negative experiences, many shipyard workers remember few occasions of racial tension on the job or in Marin City. Annie Small, a long-time African American resident of Marin City and a Marinship worker, recalled:

> Everybody got along swell because everybody acted as a family unit, everybody helped everybody else. It was such a mixture of all kinds of ethnic groups and ages, and the work habit was ... everybody worked around the clock.[3]

For more than three years, the Sausalito shipyards ran day and night employing more than 75,000 people working round-the-clock shifts. In that time, they built fifteen *Liberty* cargo ships and seventy-eight tankers, averaging one new ship every thirteen days.

At the end of the war, most of the white Marin City residents moved away and found jobs and homes around the Bay Area. Unfortunately, due to widespread racial

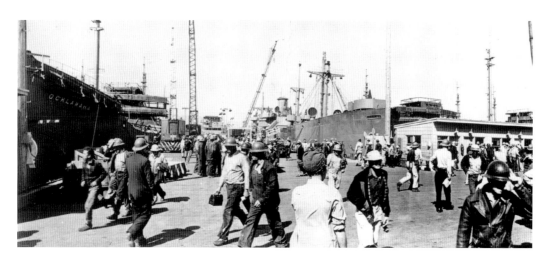

Afternoon shift change at the Marinship docks.

discrimination and exclusionary real-estate covenants, African American workers had fewer options to relocate. By the early 1960s, as the hastily built wartime housing was falling apart, Marin City was almost 90 percent African American. Over the next few decades, federal housing units and new homes, apartments and condominiums were built in Marin City and the nearby Gateway Shopping Center was completed in 1996. According to 2020 Census figures, Marin City is now home to 3,000 residents with a demographic composition of 34 percent Caucasian, 27 percent African American, 18 percent Hispanic, and 11 percent Asian/Pacific Islander. Part of the enduring legacy of Marin City is of a community that labored together to support the war effort, and the courage of the African American workers represented in *James vs. Marinship* that prohibits segregation in the workplace and protects the civil rights for all workers, regardless of race.

9

Tiburon's Blackie:
Marin's Most Beloved Horse

Most Marin residents will easily recognize the swaybacked horse in the beautiful photograph below and the location. 'Of course,' you say, 'It's Blackie, standing out in his pasture overlooking Richardson Bay.' He has become such a Marin County icon that many folks, and I include myself, believe they remember seeing him as they drove past Trestle Glen Boulevard on the way to Tiburon. However, Blackie died in 1966 so the math just will not work for those of us who have not been a county resident for at least fifty-six years. Newspaper interviews with Blackie's owners, brothers John and Anthony O'Connell (or Connell depending on which article you read), recount how Blackie was brought to California in 1926 (or 1927) from Kansas (or Arkansas) by John as a young cutting horse that worked the rodeo circuit in Northern California. Anthony, much like Daniel Peggotty in *David Copperfield*, lived in a converted houseboat on a cove of Richardson Bay having moved there in 1904. Anthony cultivated and sold clams locally for nearly forty years. Blackie was put out to pasture by the brothers around 1938 and became the beloved, solitary sentinel to several generations of travelers and residents of the Tiburon peninsula. Children who grew up in the area remember feeding him apples and carrots and virtually every peninsula resident grew to associate Blackie with their town, their neighborhood, and the less hectic days of the early twentieth century.

That connection to the past took center stage in 1965 after the train trestles at Trestle Glen Blvd. were torn down and the Tiburon Town Council approved a widening and re-routing of Tiburon Blvd. The original design for the new highway was to pass right through the middle of Blackie's Pasture, but the locals would have none of that. The Council was pressured to preserve part of the pasture and leave Blackie in peace. Blackie and John O'Connell were even invited to the November 1965 ribbon-cutting ceremony for the dedication of the new roadway. But Blackie, true to his nature, refused to cut the ribbon as urged and just stood there, staring straight ahead. Blackie went back to his pasture, a well-loved but reluctant hero.

John O'Connell died a few weeks later, but Anthony, caring for the horse from his nearby beach house continued to watch over Blackie. On February 26, 1966, Blackie collapsed while standing in his spot and could not be helped back onto his feet. A

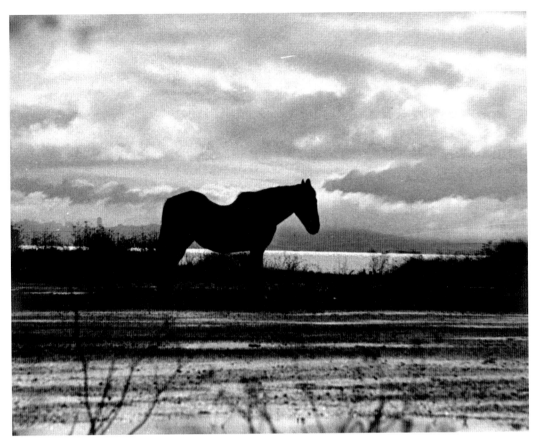

Tiburon's favorite horse, Blackie, standing in his field near Trestle Glen Boulevard, *c.* 1950.

local veterinarian was phoned and administered shots to ease the horses suffering and Blackie was humanely put to sleep the following day. Burying a horse is no easy task, and requests were made to inter Blackie in his bayside pasture even though it would violate Marin County health laws. The efforts were successful; however, when the Marin County Health Department approved his burial where he had lived for so long. A small white picket fence was erected around his grave and a brass plaque installed, telling the story of Blackie and his life. In 1995, the Tiburon Peninsula Foundation, with a gift from the family of Tiburon's first mayor, Gordon Strawbridge, erected a life-sized sculpture of Blackie by Bay Area artist Albert Guibara, in Blackie's Pasture. Now, that is something that nearly every Marin County resident has seen and enjoyed!

The Town of Larkspur: Named after the Wrong Flower

Today, as one walks, bikes, or drives through downtown Larkspur, there is the look and feeling of small-town America that has been carefully preserved. Like many Marin County towns and cities, the Larkspur area was originally hunting and gathering grounds for the Coast Miwok inhabitants and was also the site of a permanent, indigenous village. That site was recently unearthed when the abandoned plant nursery on Doherty Drive, across from Hall Middle School, was removed for the construction of new housing. The excavated site contained 600 human burials, shells, tools, musical instruments, weapons, and the bones of grizzly bears, otters, deer, and condors. The Miwok first lost their land to the Mexican Californios, and subsequently to the American settlers who followed the rush for gold and the establishment of the state in 1850.

In 1834, Irishman John Reed was given a land grant by the Mexican governor called Rancho Corte Madera del Presidio that included the future town of Larkspur. The area was vigorously logged to supply lumber for the Presidio in San Francisco. Two sawmills were in operation there and barges that were floated down Corte Madera Creek shipped the timber across the bay. By 1870, farming and ranching became the region's principal industries, but there were few homes in the area and no real town. In 1874, the North Pacific Coast Railroad laid tracks from Sausalito to Cazadero in Sonoma County following the old county road, part of which is now Magnolia Blvd. A railway station was built in what would become Larkspur, spurring growth in the area. The photograph below is taken from the entrance to that station, where today, a 1929-built railroad "warming station" still stands on the bike and walking path just east of Magnolia Blvd.

In 1886, C. W. Wright and his American Land and Trust Company purchased much of the area, subdivided the land, and piped in water from nearby Baltimore Canyon. According to legend, Wright's wife, Georgiana, named the town Larkspur, mistaking the abundant, local lupine flower for larkspur. Wright laid out the town in 1887 and the first post office opened in 1891. Larkspur became a popular weekend destination where San Franciscans could come to fish, hunt and escape the summer fog. Wright built the Hotel Larkspur in 1891 to accommodate the many summer guests and operated a saltwater bathhouse across the street from the hotel that took advantage of the then free-flowing

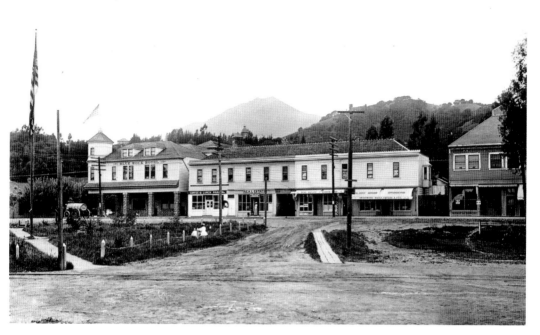

View of downtown Larkspur from North Pacific Coast Railroad train station, *c.* 1900.

slough to the bay. In 1910, Serafino Marelli and William Stringa who owned a tavern in town bought Wright's hotel, rebuilt the lower floor of the hotel using locally quarried, blue basalt rock and changed the name to the Blue Rock Inn.

The large building to the north of the hotel was owned by Richard & Bessie Lynch who replaced their small grocery store with the long, two-story structure. "Lynch Hall" housed retail shops on the lower floor including a cafe, two real estate offices, the post office and the Blake Brothers Grocery. The entire second story was a large room that served as a general-purpose meeting hall and auditorium for the town. The last building partially seen on the right was the Goerl building, built in 1891 by Fritz Goerl, a prosperous Bavarian brewer in San Rafael. It also had commercial businesses on the first floor and residences on the upper floor. For a few years it was the home to the Larkspur Drug Store, whose proprietress was a woman pharmacist named Evans Montgomery.

11

Jean Escalle's Winery, a Gold Rush and a Disappearing Town

The life of Jean Escalle exemplifies the hard work, savvy determination, and dreams of success that generations of immigrants have brought to these shores. According to a 1920 *Sausalito News* item, Jean, a native of France, came to Marin County in 1881 at the age of twenty-three and found work in Peter Prunty's Kentfield brickyard, now the site of Marin General Hospital. Escalle eventually changed jobs, relocating to the Larkspur brickworks, owned by fellow Frenchman, Claude Callot, and was responsible for taking care of the brickwork's stable of Clydesdale horses. When Mr. Callot died in 1888, Jean married his widow, Ellen. The couple continued to operate the brickworks and opened a popular inn and tavern on the property. It was called The Limerick Inn, a name suggested by Ellen who hailed from Ireland. The establishment was popular with weekend vacationers from San Francisco and featured beautiful gardens, outdoor dining, bocce ball courts, and a dance floor with a bandstand. The same *Sausalito News* item reported: "The annual celebration of the Fall of the Bastille held at Escalle became quite a feature and annually brought a large crowd of fun-loving people to Escalle's every year."[1]

Soon after marrying Ellen, Mr. Escalle cleared 23 acres of land on the hillside behind the brickworks and planted both Zinfandel and Riesling grapevines. Within a few years, the vineyard was producing more than 8,000 gallons of wine a year, making it one of the leading wineries in the county. Mr. Escalle was also responsible for one of Marin County's only gold rushes when he found a vein on his property while digging a well in February of 1899. Although the discovery never panned out there was a genuine rush of prospectors that winter to the Escalle property and great excitement generated around the county.

Jean became a leading citizen in the area, and when the North Pacific Coast Railroad built a station near the small community around his brickworks and vineyards, it was named Escalle. He was prominent on the Larkspur political scene and was elected a city trustee three times. Ellen died in 1903 and he married Wilhelmina Vogel in 1905. He retired from running the Limerick Inn but continued working the winery. To increase sales, Jean started a home delivery service and personally delivered wine to his customers

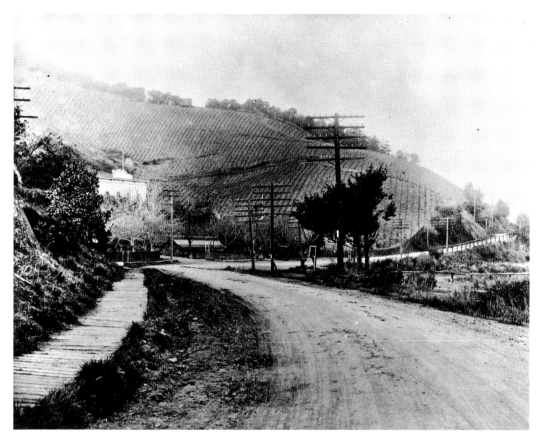

The Escalle Winery and vineyards near Larkspur.

in a horse-drawn wagon. In 1909, he fought the incorporation of the small community named after him by neighboring Larkspur but lost in court and the community of Escalle faded into history. The 1910 census lists Jean living with his wife Wilhemina, his brother Peter and Peter's two sons, Albert and Virgil at #12 County Road in Larkspur. In 1919, the Volstead Act was passed, prohibiting the sale of intoxicating liquors, and bringing an end to Escalle's winery. Jean Escalle died suddenly of a stroke at the age of sixty-two in 1920 leaving behind a legacy any citizen would be proud of. Today, if you travel along Magnolia Blvd. just north of downtown Larkspur, hidden in the trees on the west side of the road, is the original, Italianate designed false front to the brickworks and winery. Some of the Escalle estate buildings still exist and until recently hosted the annual MarinScapes art show and fundraiser for the non-profit Buckelew Programs which supports people with behavioral health challenges.

12

The Kent Family Builds its "Paradise"

William and Elizabeth Kent are prominent figures in Marin County's history. The couple donated nearly 300 acres of their land under the 1906 Antiquities Act to preserve the magnificent redwoods of Muir Woods National Monument. William was also a Progressive Republican congressman who helped establish the National Park Service and Elizabeth was a tireless and influential advocate for women's suffrage. But it was William's parents, Albert, and Adaline Kent, who first moved their family to what is now Kentfield in 1871. They purchased the land from James Ross in what was then named Ross Landing and built the home in the photograph below the following year, naming it Tamalpais. The small community that sprang up around the estate took that name for several years, but it was changed to Kent in the 1890s and finally Kentfield when a post office opened there in 1905.

Albert Kent, a Yale graduate and attorney, made his fortune as the first large-scale meatpacker in Chicago in the 1850s. He married Adaline Dutton in 1856 and they had three children, Mary, William and an adopted daughter, Mary Stearns. Having fallen in love with Marin County on an earlier hunting trip, Albert moved his family to Ross Landing when he retired at the age of forty-one. Within a year, the Kent's built their dream home in what they referred to as "paradise" and settled down to an idyllic country life.[1] Their home was in present-day Kentfield just a few blocks west of today's Woodlands Market and College of Marin. Several of the street names in the area date from the early Kent settlement such as Vineyard and Orchard roads that took their names from the crops on the Kent Estate. Goodhill Rd. was a favorite hiking trail that even the couple's small children could climb.

The Kents, like many wealthy families during the Progressive Era, felt a strong obligation to give back to their community and enhance the lives of their fellow citizens. Albert Kent donated over $100,000 to Yale University for a science center and Adaline Kent donated land near their home and paid for construction of what would become the Tamalpais Centre, an educational and recreational community center for Marin County residents. In addition to donating Redwood Canyon which became Muir Woods, William and Elizabeth Kent also gave land to the county that would become part of the

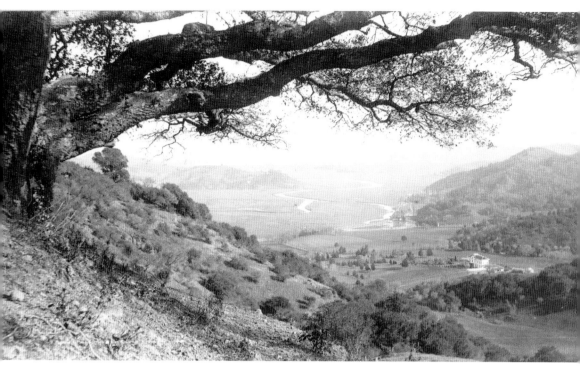

View of the Kent family estate in central Marin, *c.* 1880.

Marin Municipal Water District watershed which now supplies more than 80 percent of Marin County's water. While managing his father's businesses in Chicago, William also donated the land for the children's playground at Jane Addams' Hull House that served the immigrant poor of that city.

The Hull House donation, though laudable, has an ironic twist to it. Mr. Kent did not feel so kindly to immigrants from Asia. He, like many of his era, harbored a racial bias towards non-Europeans and was virulently opposed to immigration from China and Japan. He worked in Congress to extend the Chinese Exclusion Act of 1882 and was a particularly vocal advocate for barring immigration from Japan. Though William Kent found his "paradise" in Marin, and through his family's generosity and environmental preservation, shared that vision and legacy with countless others, it should be acknowledged that he also believed paradise as being exclusively reserved for those of European ancestry.

13
Kentfield May Day, 1909:
A Countywide Celebration of Springtime

For thousands of years, people have participated in May Day festivals that celebrated the coming of spring and the planting of crops necessary to sustain families through the autumn and winter months. That tradition of gathering to celebrate the change of seasons continued well into the twentieth century as most communities were still tied to the land and dependent on the crops or livestock they raised. In 1909, Marin County held a May Day festival that featured traditional celebrations as well as games and races for participants of all ages and gender, including the always-hilarious sack race pictured below. The unknown photographer captured the moment that the lead runner is plummeting to the ground as his closest competitor looks on with interest while completely airborne, truly "a moment in time." A few days before the festivities, an April 4 *San Francisco Call* newspaper article reported that the town of Kentfield was planning a large, countywide gathering, not only to celebrate May Day, but also to break ground for the newly proposed Marin Stadium & Clubhouse. The land for the project, 29 acres now occupied by Kent Middle School and the College of Marin Gymnasium and athletic fields, was donated by Mrs. Adeline Kent. The complex would feature a "stadium, clubhouse, swimming tank, athletic grounds, racetrack, meeting rooms and theater" and would come to be known as The Tamalpais Centre.[1]

Festivities for the May Day celebration included a formal procession of each school's May Queens and a drawing to select the Queen of the May Festival. This was followed by Maypole dancing, games, races, contests for men, women, and children, two baseball games, military drills by the Mount Tamalpais and Hitchcock military academies, music by a brass band of forty pieces and refreshments for all. Extra trains were scheduled for the day and estimates of the crowd were more than 4,000 with over 1,000 school children participating. The day's concluding attraction was a "balloon ascension and parachute drop" that thrilled the crowd.[2] Mrs. Kent, mother of Congressman and conservationist, William Kent, used a silver shovel to officially break ground that day for the $12,500 clubhouse that was designed by noted Bay Area architect, Conrad Meussdorffer. In October of that year, The Tamalpais Centre was in operation. The

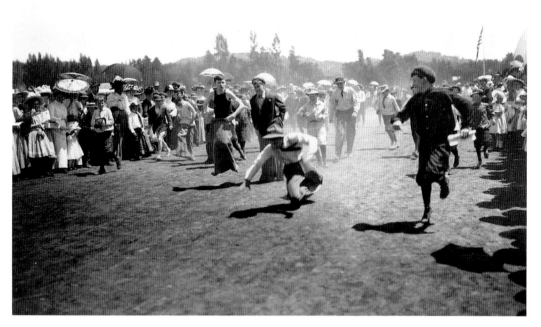

Sack Race at the 1909 Kentfield May Day celebration.

theme of community involvement and a dedication to healthy pursuits was the driving force behind the Tamalpais Centre's mission which was established, "to meet the social needs of our time and place ... wherein all of us working together may more fully enjoy the life granted each of us."[3]

14

Idyllic Marin Panorama: As Seen from "Little Tam" (Christmas Tree Hill)

Few photographs capture the beautiful, pastoral landscape of early Marin County like the one below. Taken from just above future Corte Madera and Larkspur around 1900, a young boy points northeast into the distance, at what we do not know, though the spectacular panorama was obviously of great interest both to the boy and the unknown photographer. The Old Corte Madera School, now the site of Marin Primary and Middle School, is seen to the boy's left. Early American settlers Frank Pixley and Agnes Forbes donated the land for the school in 1894. Ten years earlier, Pixley's father-in-law Captain John Van Reynegom was granted a deed to 191 acres of John Reed's land grant, Corte Madera Del Presidio by Reed's daughter, Hilarita.[1]

The Pixley land ran from the Corte Madera train station (today's Menke Park) to the top of the ridge named "Little Tam" and north to the Baltimore Park area that was owned and developed by Agnes Forbes' family. Pixley came to California by wagon train in 1848 to prospect for gold, eventually setting up for business as an attorney in San Francisco. Not only did Pixley serve the City of San Francisco as an attorney, he also sat on the San Francisco Stock Exchange, was a Park commissioner, State Assemblymen and Attorney General, a Regent of the University of California and the publisher of the influential and popular literary journal, *The San Francisco Argonaut*. In the photograph, only a few homes dot the landscape in the hills above what is currently Larkspur, and the tracks for the North Coast Pacific Railroad can be seen running off into the background on the right of the image. The railroad ran from Sausalito through Corte Madera north to San Rafael, then Pt. Reyes, Tomales and eventually Cazadero in Sonoma County. The land passed to Pixley's heirs and was eventually developed into what became known as the Owl's Wood and Chevy Chase portions of Corte Madera and Larkspur.

At the time the photograph was taken much of the area had been converted to farming and ranching after the timber industry felled most of the trees that once flourished on the foothills of Mt. Tamalpais. There was a moderate influx of new residents to the area after the 1906 San Francisco Earthquake and Fire and both Corte Madera and Larkspur incorporated in the first decade of the twentieth century. The Old Schoolhouse sits near

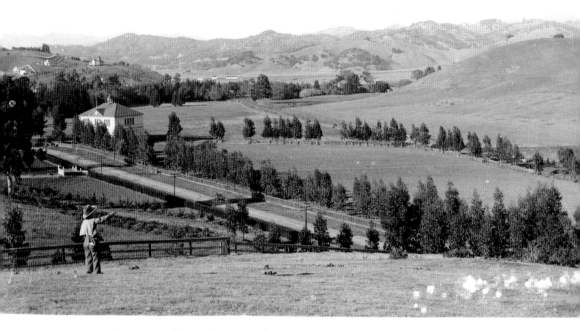

Panorama of Corte Madera/Larkspur with Corte Madera School and what is now Magnolia Avenue below, 1898.

the spot where the two city limits meet. Little Tam's name was changed to Christmas Tree Hill in the 1920s, as the holiday lighting on the hillside's zig-zag roads resembled those of a Christmas Tree. Population growth was slow until World War II when the Sausalito shipyards brought thousands of workers and their families to Marin. By the 1950s and 1960s housing subdivisions and shopping malls were springing up all over central and southern Marin and the bucolic landscapes of the past were transformed forever.

15

Dancing Under the Stars at the "Rose Bowl" in Larkspur

The decades-long popularity of Larkspur's "Rose Bowl" dances is unique in California, if not, the nation's history.[1] The dances began as an annual fundraiser for the Larkspur Volunteer Fire Department in the first decade of the twentieth century. Local lumber purveyor, civic leader, and volunteer fireman, Ralph Doherty, originally proposed the idea of the dances to fund the town's all-volunteer fire department. Initially, there was resistance to the idea, but by 1913 the benefit dance was such a success that a large wooden platform was built in a nearby redwood grove and dances were held every Saturday night from April through October for the next fifty years.

By 1938, the redwood grove just east of Magnolia Ave was purchased by the fire department and the dance floor expanded to over 24,000 square feet to accommodate the huge crowds that averaged over 2,500 and occasionally topped 4,000. Many travelled by ferry and train on spring and summer weekends to get to Larkspur where they were serenaded by popular swing and jazz orchestras. Refreshments were provided courtesy of the Corte Madera Volunteer Fire Department and other local charity organizations, and guests were treated to fireworks that included an awe-inspiring 40-foot "fire-fall," presided over by the volunteer firemen themselves. Billed as an opportunity to "Dance Under the Stars," the only other lighting for guests was provided by strings of twinkling lights and lanterns hanging from the trees that grew up through the dance floor.[2] The height of the Rose Bowl's popularity was between 1941 and 1946 when thousands of soldiers from nearby bases flocked to the grove for an evening of dancing and female companionship.

Incredibly, with profits from the Rose Bowl dances, the Volunteer Fire Department provided the small town of Larkspur with one of the finest equipped departments in the United States. A 1930 industry survey noted that the department purchased all the modern fire-fighting equipment without once resorting to taxing the local inhabitants. The dances continued to draw large crowds over the next fifteen years, but by the early 1960s, with attendance waning, organizers decided to discontinue the annual festivities and sold the property to a developer. An apartment complex now sits on the site of the Rose Bowl dance floor, but the music and merriment of those bygone years is still remembered by the many thousands who danced the night away "under the stars."

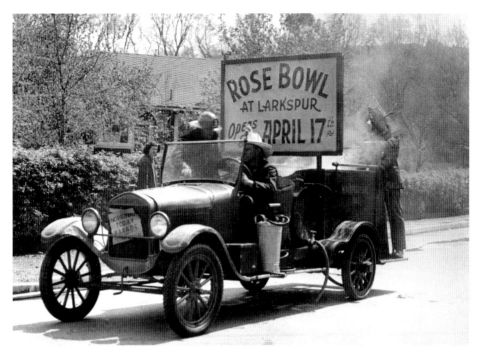

Larkspur Fire Department vehicle promoting the "Rose Bowl" dance, 1940. (*Photograph by Madison Devlin*)

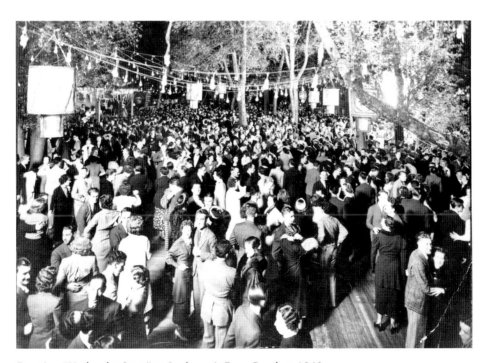

Dancing "Under the Stars" at Larkspur's Rose Bowl, *c.* 1940.

16

Meadowsweet Farms Dairy: Providing "Milk and Cream of Unsurpassed Quality"

From its earliest days of statehood, Marin County has been home to cattle and dairy ranching. Beef cattle dominated the early years but soon gave way to dairy ranching as San Francisco's population continued to grow after the discovery of gold. By the 1870s many Swiss and Portuguese immigrants began settling in Marin to raise cattle and operate dairies that shipped butter, cheese and milk to the growing city. The towns of Tomales and Bolinas were important shipping ports along with smaller wharves on the Pt. Reyes Peninsula and Tomales Bay. By the early twentieth century, there were hundreds of individual dairies thriving throughout the county.

One of the largest and most modern was the Meadowsweet Farms Dairy in what is now Corte Madera. Established in 1929, it sat nestled against the hills just south of today's Tamalpais Dr. The dairy was the brainchild of Frank Keever and his wife Hazeltine Sherman. Frank was a Canadian-born engineer who made a substantial fortune in the mining business and Hazeltine was the daughter of Harriet and Moses Sherman, a wealthy land developer and railway owner in southern California. The Shermans had previously bought 60 acres of land named Overmarsh next to their home in Corte Madera. That parcel was once part of the San Clemente Stock Farm owned by the Valentine brothers, Thomas and Samson. The brothers raised horses and raced them on a mile-long track adjacent to the railroad line, near today's Village Shopping Center. Keever then purchased a large tract of nearby marshland and drained the area with a complex system of floodgates creating over 1,400 acres of prime pastureland.

The Meadowsweet Farms Dairy became the model for modern Marin County dairies. They imported pure-bred Guernsey cows, purchased state-of-the-art milking machines, tested their stock for disease, and insisted on ultra-sanitary conditions throughout their dairy operations. Meadowsweet originally produced Grade A Raw milk but expanded their product line over the years to include pasteurized milk, buttermilk, cottage cheese, butter and eggs. For the next fifteen years, Meadowsweet Dairy was the principal industry in the area and was described as "a state-of-the-art dairy to produce milk and cream of unsurpassed quality."[1]

The Keever's eventually divorced in 1937 and the delivery routes were sold to rival, Borden Dairy. The dairy and its 1,400 acres of pastureland were sold to Hugh Porter

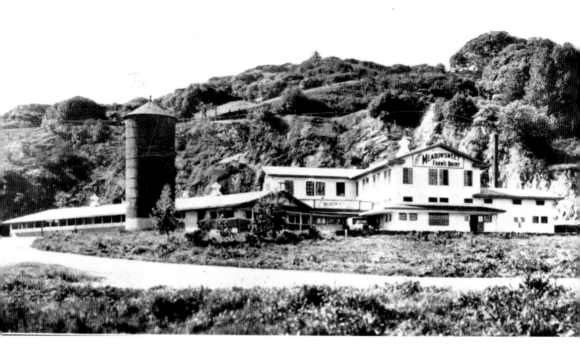

Corte Madera's Meadowsweet Farm's Dairy, 1931.

for $225,000. Porter expanded the operations of the Meadowsweet plant and operated it under the Marin Dell Dairy name, which he had recently leased. The Meadowsweet Dairy name lived on, however, as the Sherman family shipped their herd to Calexico where they operated a new Meadowsweet Dairy along the border of California and Mexico.

An interesting and somewhat amazing postscript to this story is that the young man who helped ship the Sherman's stock to Calexico and would go on to be the new dairy's manager for close to twenty years was one Paul Glud. Why, amazing? Because in 1931 when he was just twenty-two years old, the following notice appeared in the *Petaluma Argus-Courier*:

Dairy Hand Was Gored By Bull—His left lung punctured by the horn of a bull suddenly gone mad, Paul Glud, 22, Corte Madera dairy employee is believed to be dying at Ross General Hospital. Fellow employees rescued him from the infuriated animal as it set itself for a second attack. Glud, an employee of the Meadowsweet Dairy at Corte Madera, attempted to beat down the attack with a heavy shovel as the bull charged.[2]

17

Greenbrae Rod & Gun Club Hosts Hamilton Field Airmen

Throughout World War II, the Greenbrae Rod & Gun Club annually hosted convalescing airmen from nearby Hamilton Field for a striped-bass fishing expedition at their clubhouse on the Greenbrae boardwalk. Club members loaded upwards of eighty airmen into more than twenty-five member boats and provided the soldiers with boxed lunches and an ample supply of beer that was ferried out to each boat "whenever a white flag was raised."[1] After a day on the bay, the Ladies' Auxiliary served a large meal at the Clubhouse, glasses were raised in toasts, and all of the day's catch was packed in ice and sent to the Hamilton Field kitchens to be served to airmen unable to make the trip.

The Rod & Gun Club was established in 1926 by local sportsmen who met in each other's homes for the first few years. By the end of the 1930s, membership increased to such an extent that the group began searching for a site to build a clubhouse. Many members lived on "arks," or houseboats, along the Greenbrae boardwalk just across Corte Madera Creek from today's Larkspur Ferry Terminal. A large plot of land was purchased there, and the clubhouse was built and dedicated in June 1940. Throughout the war years and the 1950s, the Greenbrae Rod & Gun Club flourished, with a membership of over 200 and the clubhouse was the location for many events including the annual St. Patrick's Day Dinner and Dance. A 1959 *Sausalito News* article reported that, "the Club will celebrate the nineteenth annual St. Patrick's dinner dance featuring dinner and a full evening of dancing and entertainment with George Hall Jr. and his Greenbrae Hotshots furnishing the music."[2]

The Club also hosted an annual fishing trip and picnic for boys and girls from the Sunnyhills School in San Anselmo and the St. Vincent's School for boys in Marinwood. After the three-hour fishing trip, the children and teens enjoyed numerous carnival-style games at the clubhouse, ate a sumptuous meal, and ended the day with a talent show that the students performed themselves. Along with their charitable work, the Club was also instrumental in opposing two separate attempts to place explosive-laden barges off San Quentin Point and McNear's Beach in 1949 and 1952, respectively, and lobbied against the placement of a garbage dump in Greenbrae in 1954.

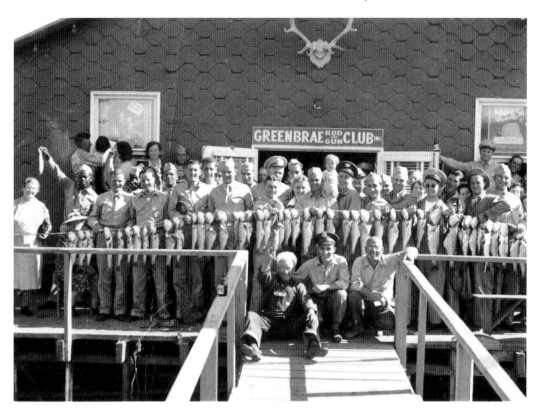

Hamilton Field airmen display the day's catch from the annual striped-bass fishing outing sponsored by the Greenbrae Rod & Gun Club, 1944.

By the early 1960s, membership in the club was decreasing and many charter members had died. The clubhouse still served as a meeting place, but newspapers of the decade began advertising rummage sales at the property to benefit the Greenbrae Improvement Club and notices that the clubhouse would serve as a polling location for voters. In 1973, the Rod & Gun Club was dissolved, and the clubhouse became the home of the Crossley Bridge Center which moved from its home in San Rafael and began hosting contract bridge classes and tournaments in the building. The Center closed its doors in 2018 and the property, along with the clubhouse was recently listed on the real estate market for just under $1,000,000.

18

San Anselmo's "Hub": The Historic Crossroads of Marin

The San Anselmo "Hub," formerly known as "Junction," has been the principal intersection in Marin County for more than 150 years.[1] During the horse and buggy days of the land-grant era there were blacksmith and carriage maker shops at the crossroads serving travelers heading east or west on the San Rafael to Olema Road and south to Sausalito. In 1874, the North Pacific Coast Railroad extended their line from Sausalito to San Rafael via the Junction, and in 1875 laid tracks west through Pt. Reyes Station and Tomales north to the Sonoma County timberlands.

For several years, the unincorporated settlement in the vicinity was referred to on railroad maps simply as Junction and there were just a few scattered homes in the area. In the 1880s, railroad officials wanted to encourage development along their routes and began using the name San Anselmo which was part of the original land grant name given to John Rogers Cooper by the Mexican government. In 1892, the newly constructed San Francisco Theological Seminary relocated to what was called the "Sunnyside" subdivision and the town began to grow.[2] The early settlers were soon joined by a wave of new residents fleeing San Francisco after the 1906 earthquake or looking for more sunny environs to build their homes. The first photograph below, taken around 1900, features the hilltop Seminary in the background, the train tracks coming from San Rafael in the foreground, with the train station and its water tower and an out-building to the right of the road. Just to the left of the road sits the grocery store and candy shop owned by Mrs. Needham, one of the earliest business establishments in the town.

With the coming of the automobile, the intersection took on a whole new life as roads paralleled the railroad tracks and first hundreds, then thousands, of motorists passed through it daily. The second photograph below was taken in 1949 from atop the distinctive Spanish Colonial Revival building that still stands today on the north side of Sir Francis Drake Blvd. It was designed by noted architect Sam Heiman in 1924 and housed the Durham Garage that also included a Dodge sales and showroom. For many years Pavilion Antiques occupied the building and in a return to its original use, it is now home to California Tire & Wheel. Though the intersection and some of the buildings are very recognizable there are significant differences from today's configuration.

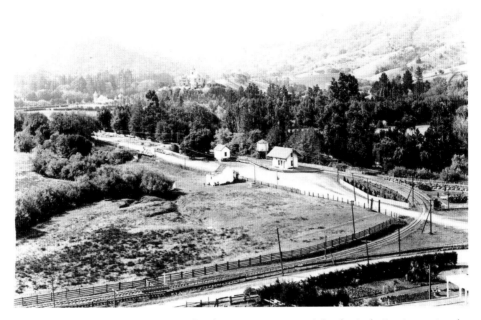

The "Junction" train station with the San Francisco Theological Seminary in the background, *c.* 1900.

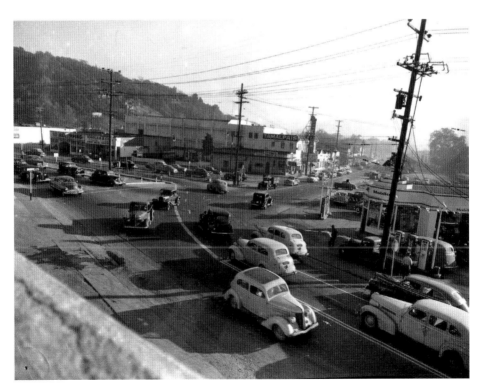

Traffic at San Anselmo's "Hub," 1949.

Notice that there are no traffic lights and the automobiles traveling west to east from Sir Francis Drake Blvd. on to what is commonly known as the "Miracle Mile" have an unrestricted right-of-way. Motorists driving from San Rafael to points west have a stop sign as do the automobiles approaching the Hub from downtown San Anselmo and Ross. Also, Center Blvd. is offset from the main intersection and is directly across from the entrance to the current Greenfield Ave. There is Mobil Gas station in the lower right of the image with a few customers filling up at the pumps where today there is a small, enclosed parking lot just east of the Safeway Community Market. Other businesses seen in the photograph are the Tamalpais Theater in the center background, also designed by Sam Heiman, the Meagor Pharmacy next door where the New China Villa Restaurant is today, and farther east on Greenfield Avenue; Knoles & Co. Sheet Metal & Heating that provided furnaces and heating equipment along with sheet metal for gutters and flashing. Just to the left of Knoles & Co. can be seen a business whose sign reads on closer inspection, "Recapping," as in retreading tires, home to the Cain & Jonasen Tire Service, an earlier forerunner of the modern-day Cain's Tires of San Rafael.

Though relatively busy at the time the photograph was taken, a 2017 transit study found that San Anselmo's Hub was the most congested intersection in Marin County with over 65,000 cars passing through it every day. No doubt, that number has increased in the ensuing five years. Though traffic congestion at the intersection can be frustrating, the Junction, or Hub, has served the same purpose for generations of Marin County residents and visitors and we really could not do without it!

19

Captain Robert Dollar
and Falkirk Mansion

The beautiful, Queen Anne home at 1408 Mission St. in San Rafael, now the Falkirk Cultural Center, was once home to shipping and timber magnate Robert Dollar. Captain Dollar, as he was known, purchased the 11-acre parcel from Ella Park's estate in 1906 and named it after his hometown of Falkirk, Scotland. According to the Center's website, Ms. Park, the young widow of attorney and financier, Trenor Park, built the home in 1888 after purchasing the land from railroad entrepreneur James Walker. To design the home, she hired architect Clinton Day, who also designed San Francisco's City of Paris building, the Union Trust building, and Gump's department store.

Robert Dollar's American Dream, success story began in the lowlands of Scotland as an errand-boy for a lumber company when he was only ten years old. In 1857, he emigrated to Canada with his family at the age of thirteen and held many jobs in the timber trade including riding the logs down river for delivery to the mill. He worked in lumber camps in both Canada and Michigan, eventually earning enough to purchase his own timberland in Canada, Michigan, Northern California, and Oregon. In 1874, he married Margaret S. Proudfoot who would be a close, lifelong companion on all his travels and ventures. The couple had four children when they moved to San Rafael in 1888. In 1893, he purchased a steam schooner, *The Newsboy,* to transport his lumber along the Pacific Coast, establishing the Dollar Steamship Company. Within a few years, his fleet of steam-powered ships grew to over fifty vessels providing transport for his four shipping companies and numerous timber firms. In 1902, after traveling to Asia, Dollar began operating a trans-Pacific trade with Japan, China, and Singapore, including the first-ever chartered passenger voyages to Japan and the Philippines. By World War I, Robert Dollar was one of the richest men in America and his shipping fleet was plying trade around the world and opening new markets across the Pacific Ocean.

After Ella Park's death, the Dollars purchased her home on Mission Ave and moved their family into the grand Victorian era residence. Along with managing worldwide shipping and timber interests, the Dollars were also generous benefactors in their adopted home of Marin County. They donated land and funds to build the original Sunny Hills Orphanage in San Anselmo, endowed a Chair at the San Francisco

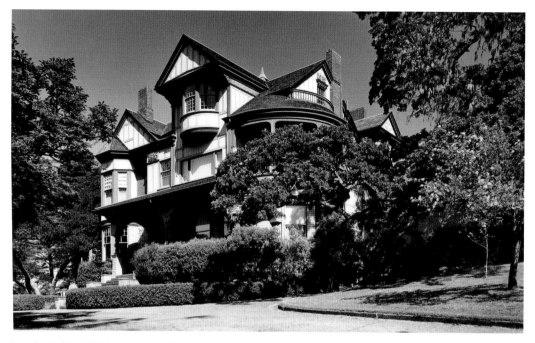

San Rafael's, Falkirk Mansion, home to shipping magnate, Robert Dollar. (*Photograph by Paul Cleveland*)

Theological Seminary, and donated 31 acres to the City of San Rafael for Boyd Park and the access road to the summit of San Rafael Hill that bears his name. Mr. Dollar did not forget his birthplace of Falkirk, Scotland, donating funds for a public park and community center, a library, and a monument commemorating the 1298 battle of Falkirk in the First War of Scottish Independence. A few years before his death in 1932, Dollar responded to a reporter's question about retiring.

> I was eighty years old when I thought out the practicability of starting a passenger steamship line of eight steamers to run around the world in one direction.... I hope to continue working to my last day on earth and wake up the next morning in the other world.[1]

After his death, two of his sons took over management of the company, but the Great Depression took its toll on the family's fortune and all the shipping interests were sold to pay off the company's debt. Falkirk Mansion was sold by the Dollar family and by the early 1970s had fallen into disrepair. Falkirk was nearly razed to the ground in the 1970s to build a large condominium and apartment complex on the site. However, the stately home survived due to the hard work and dedication of Mary Dekker of Marin Heritage. She and her organization successfully petitioned San Rafael Mayor Larry Mulryan and the City Council to help preserve the historic site. Falkirk now serves as a Community Center for art exhibits, Master Gardener classes, and as a celebration and wedding rental facility where, among many others, the author of this article wed his lovely wife in 1981.

20
The Dominican Sisters
Come to San Rafael

The story of the Dominican Sisters of San Rafael and Dominican University began with a papal summons to Rome in 1850. The summons came to Prior Joseph Alemany, a naturalized United States citizen born in Spain, who was sent as a missionary to the United States ten years earlier. Reluctant to take the position, he relented when Pope Pius IX told him, "You must go to California, where others are drawn by gold, you must carry the Cross."[1] Before embarking on his journey, Alemany sought to bring along a few Dominican Sisters to help educate the children of his new diocese in California. The only sister who volunteered to accompany him was a forty-one-year-old Belgian novice, Mary Goemaere, from Paris' Monastery of the Cross. At first, she believed she was going to live and work in Somerset, Ohio, where Alemany formerly worked. However, in route, her destiny changed and she, along with Alemany and fellow Dominican Friar, Francis Vilarrasa, began their long and arduous trip to Monterey. The journey included four separate sea voyages, and a canoe and mule-back trek over the Isthmus of Panama. They arrived in San Francisco on the steamer, *Columbus*, on December 6, 1850.

The following spring, Sr. Mary Goemaere followed Bishop Alemany to Monterey and within three years there were nine sisters teaching at the school they named Santa Catalina. In 1854, the convent and school, renamed St. Catherine's, moved inland to Benicia which had recently been designated the new capital of California. Sr. Mary continued as prioress general until 1862 and her last act was to open a convent and school, St. Rose Academy, in San Francisco.

In 1888, at the urging of Mother Louis O'Donnell, Archbishop Riordan of San Francisco approved the move of the Dominican Sisters to San Rafael. The site purchased was in what was then referred to as Magnolia Valley and was selected for its park-like setting and fine weather. The owner of the land, William T. Coleman, donated half of the land and sold the other half to the Dominican Sisters for $10,000, to be paid off as a loan. The main building was built and dedicated in 1889 and welcomed young girls the following year to what would be called The College of San Rafael. The new, ornate, Victorian-Renaissance-style building housed the convent, novitiate, and the lower and upper schools for girls.

San Rafael's Dominican College convent and dormitory, 1890.

In 1915, with the encouragement of U.C. Berkeley, a junior college was opened for young women seeking an advanced degree. In 1917, it became an accredited four-year college. The following year the sisters purchased the nearby Meadowlands from M. H. De Young and built what is now the Forest Meadow Amphitheater that has been the site of countless plays and concerts for over 100 years. The four-year college and schools for younger girls flourished together until, in 1965, the lower schools were moved to their new site in Sleepy Hollow and renamed San Domenico. In 1971 Dominican College became coeducational and in 2000 was accredited as Dominican University of California. Unfortunately, the original convent, built entirely out of redwood, was destroyed in a 1990 fire started by painting contractors who were refurbishing the building.

21
Pastori's Villa:
A Little Taste of Italy in Fairfax

When you drive or bike west on Center Blvd., the old railroad right-of-way, just before entering the downtown business district of Fairfax you will have to stop at the intersection of Pastori Ave. and Center Blvd. It you were to travel back more than 100 years you would be at the Pastori rail station named after Charles and Adele Pastori and their popular Italian restaurant. In 1893, the Pastori's leased the old Lord Charles Fairfax property and named it the Fairfax Villa. Both Adele and Charles were known as excellent chefs and with their connections to San Francisco society, Adele was a former San Francisco opera singer and Charles a set designer and builder, assured their establishment a continuous and often glittering clientele from the San Francisco stage and musical community. Within a few years, they changed the villa's name to Pastori's which enjoyed a worldwide reputation for fine dining.

They purchased the land in 1905 and made the town of Fairfax a culinary and resort destination by adding lodging for overnight and extended visits. They had four children, Ione, Enrico, Clementina, and Umberco, who grew up on the property, as their family's living quarters were on the second floor of the villa. The restaurant attracted visitors not only for its fine food, but also its beautifully landscaped grounds and the pleasant and temperate outside dining experience afforded by a large, covered porch and dining area. Period advertisements for the restaurant touted it as, "The Ideal Place. Open the year round. Cooking unsurpassed. Meals served under the trees."[1]

The Pastoris were also a civic-minded family, helping to establish and build the first schoolhouse in Fairfax where Charles served as trustee for many terms. They also raised funds for Italian victims of the 1908 Strait of Messina earthquake. At the height of the family's success, tragedy struck twice in 1911. Charles died of heart failure at the age of fifty-eight and the Villa burned down six months later. Undaunted, Adele rebuilt home and restaurant on an even grander scale, adding more cottages and rooms for guests and a maple dance floor for parties and events. In 1913, a banquet and dance in support of the San Anselmo Fire Department drew 125 guests to the Villa and was described as a "Brilliant Event" and "the finest affair that ever took place in the valley."[2] She also built a platform in one of the large oaks near the dining room, where it is said Irving Berlin

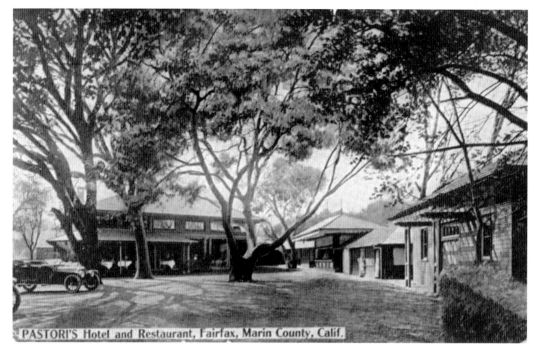

PASTORI'S Hotel and Restaurant, Fairfax, Marin County, Calif.

The Pastori Villa Inn and Restaurant in Fairfax, *c.* 1915.

once played a piano that was hauled aloft to serenade the dining guests. The photograph above is on a postcard that was written in November 1914 from a guest to his sister in Alma, Michigan. The note on the reverse reads: "Dear Sister, There's loads of fun to be had if one goes after it—with a big bunch from the rowing club, made this place lively Sunday night. Lee."[3]

Adele and her children operated the establishment until a declining business environment and Prohibition led her to sell the property in 1925. It was bought by the San Francisco-based Emporium Capwell Department Store as a resort for their employees. The company installed a large pool, tennis courts, baseball diamonds, dormitories, and additional cottages. The resort was very popular and well attended but was eventually closed and leased to the Marin School for Boys in 1937. In 1944, San Francisco businessman Max Friedman bought the property adding more swimming pools, stabling for horses, additional dance floors and summer cabins and christened it, The Marin Town & Country Club. The popular recreational club welcomed day visitors and overnight guests for many years until it closed in 1972. The 25-acre property is now a private, gated residential area, but has remained virtually undeveloped over the last fifty years.

22
Hotel Rafael:
Luxury, Scandal, and Arson

The elegant Hotel Rafael, built in 1888, was Marin's first luxury hotel and soon became the center of San Rafael "high society." Designed after the Del Monte Hotel in Monterey, the Bay Area's social elite came by ferry to Marin and then traveled by train or horse and carriage to the Dominican area hotel. Up to 225 guests could enjoy the 101 rooms, and activities such as horseback riding, bowling, billiards, dancing, golf and sailing, followed by fine dining and drinking in a first-class restaurant and saloon. The hotel's tennis courts were also the location for the annual Pacific States Tennis Tournament where local athletes could compete against nationally known players from the Western United States.

In 1895, Mary Ellen Donahue, the daughter of industrialist and railroad magnate Peter Donahue, inherited the hotel as part of her father's $12,000,000 estate. She and her husband, the wealthy, German-born Baron von Schroeder, bought out the partners in the hotel and expanded its operations. Within a few years, the baron's dissolute, scandalous parties and his behavior towards female guests soon put the hotel in financial and legal trouble resulting in one of the first "show trials" of the twentieth century. In December 1900, the baron brought a $250,000 suit for libel against John D. Spreckles and his *San Francisco Call* newspaper for printing the accounts of hotel guests who were shocked at what they had witnessed. Newspaper headlines reported on the "Midnight Orgies and Drunken Revels" that the Baron hosted, and the damage to the hotel's reputation that the "Shocking Immoralities and Gross Festivities" visited upon the establishment.[1] The jury spent less than three hours deliberating and found in favor of Spreckles and "*The Call*", further tarnishing von Schroeder's reputation. Though the Hotel Rafael was never very profitable under the von Schroeder's, life returned to normal after the trial, and the wealthy clientele returned to enjoy the hotel's accommodations and the many sports tournaments, banquets, and local events it hosted.

In 1910, the baron, ignoring San Rafael officials' safety concerns, refused to install fire escapes in the hotel and shuttered the building. At the outbreak of World War I, von Schroeder returned to Germany to take up duties as an officer in the German

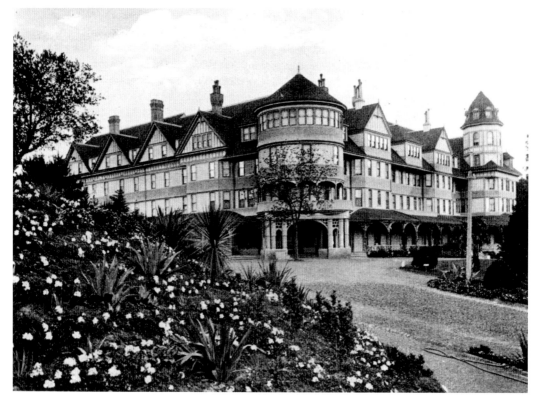

Entrance to the luxurious Hotel Rafael, *c*. 1900.

Army and left the hotel and his other properties in California deeply in debt. When the United States entered the war, the hotel was "confiscated by the U.S. government's Alien Property Custodian" and held in receivership until the debts could be paid.[2] The hotel and grounds fell into disrepair and numerous efforts to reopen or purchase the property never materialized. In 1918, the hotel was converted into a hospital to care for those suffering from the devastating, worldwide influenza epidemic and the convalescing soldiers injured in the war. Both the Dominican Sisters of San Rafael and Red Cross volunteers nursed patients on the site for the duration of the pandemic.

In 1921, the Hotel Rafael reopened for business and the new owners restored the grounds, installed electric lighting in all the rooms along with fire escapes, an elevator, and forty private bathrooms. The refurbished hotel hosted Chamber of Commerce events, receptions, dances, weddings and proms in a return to its glory days. Three years later, the hotel was purchased by the Van Noy Interstate Company which planned to operate hotels from San Rafael to Eureka to serve the growing number of automobile travelers interested in visiting the Redwood Empire. Tragically, on Sunday, July 29, 1928, a fire started in one of the upper floors and the damage was so severe that the hotel was razed to the ground, though there were no serious injuries to guests or firefighters.

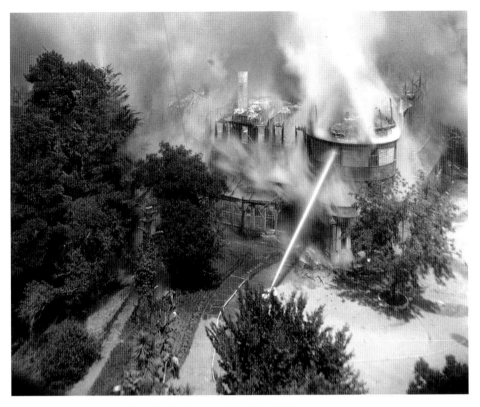

Aerial view of the Hotel Rafael in flames, July 29, 1928.

A few weeks later, an eighteen-year-old convicted arson and pyromaniac, William Harrison Fisher, was arrested in Oakland and confessed to setting the blaze. Fisher had been incarcerated in the Eldridge State Institution in Sonoma County since he was fourteen for numerous arson convictions. He had recently escaped and fled to Colorado where he was arrested and sent back to Oakland to live with his grandmother. During the few weeks he was living in Oakland, he torched the Hotel Rafael, an apartment building in Alameda and two other hotels in the East Bay. He was known to local fire houses for his past arson convictions, and they put the police on his trail. Fisher told police he enjoyed setting fires and then watching the firemen and their equipment arrive at the location and attempt to put out the infernos. In San Rafael, he took police and fire authorities on a tour of the hotel burn site and described in detail how he did the deed and what he remembered of that day's "excitement."[3] His knowledge of the event was so accurate that the San Rafael fire chief stated, "He must have been at my heels all afternoon ... he has told of incidents it would be impossible for him to describe had he not been present."[4]

23

Bicycling in Marin, 1890s Style

The bicycling craze that began in the 1890s has flourished in Marin well into the twenty-first century where the innovation of the mountain bike and mountain biking evolved into the popular sport and pastime that it is today. Pictured below is the San Rafael Wheelman bicycle club enjoying a well-earned repast after a day of cycling around Marin. Some of the club members sport a pullover sweater with the initials SR intertwined together, and at least three are seen pouring an unknown beverage from bottles into another club member's glass.

The San Rafael Wheelmen, also known as the San Rafael Cyclers, organized pleasure outings and fiercely competitive races, two of which the *Sausalito News* described as "by far the most exciting which have ever taken place on this side of the bay. Some of the fastest amateurs in the State will participate."[1] An August 1896 *Marin Journal* article stated:

> Not less than five hundred wheelmen will throng the streets of San Rafael on that date.... If our enterprising restaurateurs have not done so already, they should set about to place themselves in a position to provide good cheer that day for a delegation of hungry cyclers.[2]

For the 1899, July 4 celebration, bicyclists were invited from around the county to participate in a July 3 "Bicycle Parade" from San Rafael's west end to the elegant Hotel Rafael in the Dominican neighborhood. Participants were encouraged to decorate and festoon their bikes for the celebration in a competition for prizes that ranged from an "$8 Kodac [sic] Camera for the lady's wheel, a $9 carving set for the gentleman's wheel and an $8 set of dishes for the tandem" bikes.[3]

Although men dominated in the races and clubs, cycling also became a popular activity for women as social norms began to change at the end of the nineteenth century. Women enjoyed the freedom, mobility and camaraderie that bicycling offered. Suffragette Susan B. Anthony, interviewed by the *New York World*'s famed reporter, Nellie Bly, said in 1896:

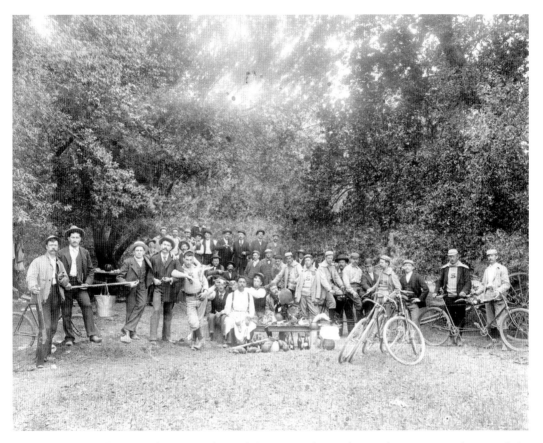

The San Rafael Wheelman Bicycling Club resting after a day's ride, *c.* 1890. (*Photograph by MacMillan*)

> Let me tell you what I think about bicycling. It has done more to emancipate women than anything else in this world.... It gives her a feeling of self-reliance and independence the moment she takes her seat ... and away she goes, the picture of untrammeled womanhood.... I stand and rejoice every time I see a woman on a wheel.[4]

For all of us who bike the roads and trails of Marin, however we self-identify, Ms. Anthony's words still ring true!

24

Mt. Tamalpais Military Academy: "The First of Its Kind on The West Coast"

The area in and around today's Marin Academy High School campus in San Rafael has been home to many educational institutions dating all the way back to the early 1870s. *Marin County Journal* articles and advertisements from 1872–1877 mention the San Rafael Academy, a boy's school run by Mr. Bates near 5th and E streets. In late 1874, the Academy merged with The Young Ladies Seminary of San Rafael, moved down the street and was renamed the Tamalpais Academy. It was mainly a preparatory school for girls that taught, "French, German, penmanship and reading … and all the branches necessary for the qualification of public-school teachers."[1] The school also had classes for boys under ten years of age and Mrs. N. J. Ashton was its first principal.

The school was near the Tamalpais Hotel which opened in March 1871 and was "handsomely furnished, with 56 rooms, a dining hall, and a billiard room, with an omnibus connection to the downtown train depot."[2] Small cottages for guests were added a few years later as the hotel went through several renovations and proprietors who leased the building from Michael J. O'Connor and his wife, Fanny, after his death in 1889.

On September 16, 1890, The Mount Tamalpais Military Academy (MTMA), a branch institution of the Mt. Tamalpais College, opened its doors to young boys at the corner of 4th and E Streets. The Rev. Arthur Crosby, pastor of San Rafael's First Presbyterian Church, was instrumental in raising the funds for the school and the Reverend J. E. Wheeler was its first principal. Annual tuition costs were $320 per year for boarding and tuition and an additional $55–75 for two different academic programs. A year later the school moved up to Fifth St. and the Tamalpais Hotel and cottages were purchased from the O'Connor family by local businessman Arthur Foster and donated to the school. The spacious hotel building, pictured below, became the living quarters for the students and by 1893 the MTMA was accredited by U.C. Berkeley and boasted that it, "Prepares thoroughly for College, the Government, Academies and business."[3] At the time, the Academy was advertised as the first of its kind on the west coast.[4] The curriculum also included rifle and infantry drills and mounted artillery training and fielded numerous sports teams that competed around the Bay Area. The school also formed a large military band that played at local celebrations, holidays, and parades.

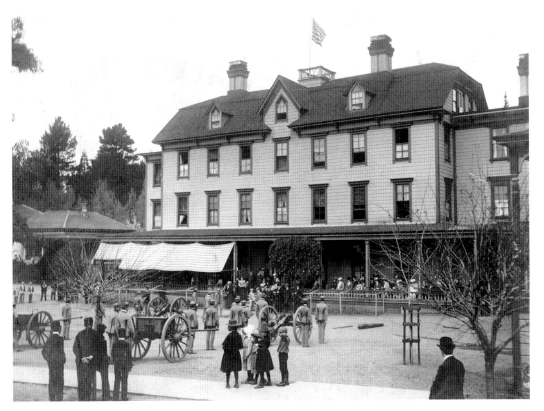

Alumni Day at San Rafael's Mt. Tamalpais Military Academy, 1901.

The photograph above was taken on Alumni Day, 1901, when over 150 guests were welcomed to the school to watch artillery and infantry drills in the morning, followed by lunch in the lavishly appointed dining hall with a reception and dance in the afternoon. By this time, the Rev. Arthur Crosby had become the Academy's headmaster.

In 1925, decreasing enrollment forced the shareholders to sell the school and its facilities to Mr. A.L. Stewart, an administrator at the school who renamed it The San Rafael Military Academy (SRMA). He expanded the campus, increased enrollment and brought four World War I dormitories from Mare Island in Vallejo to house the expanding student population. Within a few years, the venerable, old Tamalpais Hotel building was torn down as a potential fire hazard. In 1959, the Episcopal Diocese of California purchased the school, and it remained a military style academy well into the 1960s.

By the end of the decade, military and single-sex schools were experiencing falling enrollment and increasing economic hardship. The Episcopal Diocese was unable to form a consensus on how to proceed, closed the school, and dissolved their board of directors. A new board was elected and the vision of establishing a progressive, independent high school came into being. In 1972, Marin Academy welcomed its first students. The school's curriculum based on high academic standards, a full athletics program, fine arts education and experiential learning has made it a leader in the Bay Area independent school movement.

25

China Camp:
The Short-lived Refuge of Marin's
Early Chinese American Community

China Camp near Pt. San Pedro in San Rafael was once a thriving fishing village and home to thousands of Chinese American shrimpers and their families. Early Marin and Sonoma pioneer, John McNear purchased the Pt. San Pedro land in 1868 and operated a nearby dairy and brickworks. In 1870, only seventy-seven Chinese were living in the area, but by 1890 estimates numbered into the thousands. The rapid growth of China Camp has been linked to the passage of the 1882 Chinese Exclusion Act which barred virtually all immigration from China. With assistance and support of Mr. McNear, hundreds of Chinese Americans fled virulent anti-immigrant sentiments in San Francisco to relocate near Pt. San Pedro. He sailed his own ship, the *Josie McNear*, to San Francisco offering many Chinese families safe passage and jobs on his land. More than 500 Chinese accepted, and within a few years the community was flourishing as a major northern California producer of shrimp for local consumption and export. Every year, China Camp shrimpers pulled millions of tons of shrimp from around the San Francisco Bay, exporting 90 percent to China. At its peak, the town had multiple piers for the shrimp boats, houses built on stilts over the bay and several commercial buildings serving the residents. On the hill behind the beach were vast tracts of vegetable gardens and drying beds for the shrimp.

By 1910, due to discriminatory laws that outlawed shrimp exports and the use of bag nets, the Chinese American population dwindled to a few hundred residents though shrimping was still a profitable business for those that remained. In the 1940s and '50s, sport fishing for striped bass off Pt. San Pedro brought new business to China Camp from local fish and game enthusiasts. Newspaper accounts from the era describe in detail the catches of the day. A 1957 *Daily Independent Journal* advertisement encouraged fisherman to visit China Camp and, "Get out where the fish are biting."[1] These same enthusiasts were instrumental in helping to successfully block an attempt by the navy to move a large ammunition ship anchorage from Hunter's Point in San Francisco to Pt. San Pedro.

For three decades, Henry & Grace Quan, the last of the original Chinese families at China Camp, rented boats, ran a snack bar and saloon, and sold fresh shrimp to local

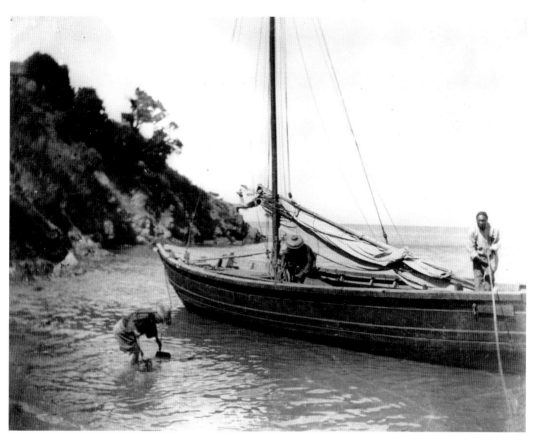

Chinese shrimp fishermen anchored off China Camp. (*Photo courtesy of San Francisco Maritime Museum*)

markets. Hollywood came calling in 1955 for the filming of the movie *Blood Alley,* starring John Wayne and Lauren Bacall. A few the Quan family were hired as extras and this relatively early film footage of China Camp can give today's viewers a sense of what the community was like. In 1961, plans were made to develop housing in the area and build an upscale marina and restaurant where the village now stands. Fortunately, the China Camp property never saw the blades of the bulldozers. The land was purchased by California in 1976 and in 1980 China Camp State Park was established preserving the historic site for all to enjoy in perpetuity. Frank Quan, China Camp's last resident, died at the age of ninety in 2016.

26

Champion Boxer Joe Gans & Billy Shannon's Villa

Joe Gans, nicknamed "The Old Master," is still considered by many boxing aficionados as the greatest lightweight fighter of all time.[1] Gans became the first African American title holder in the United States winning the title from Frank Erne in 1902 on a first-round knockout. Mr. Gans is also recognized as one of the first fighters to utilize a scientific approach to his bouts, gauging his opponents' weaknesses, using sophisticated body position and footwork on both offense and defense and being one of the earliest boxers to employ the "jab" with great effectiveness. Joe's fighting career spanned the years 1891–1909 and he was lightweight champion from 1902–1908.

The first decade of the twentieth century was the very heart of the racist, "Jim Crow" era in America. It is astonishing that an African American boxer could overcome all the obstacles of racism to not only ascend to the title but also garner the fame and respect that were afforded him by many in the sports and boxing world. A 1910 *San Francisco Call* article, commenting on his early death at the age of thirty-four from tuberculosis proclaimed, "With the passing of Gans, the 'Old Master', the Queensberry ring loses one of the greatest, if not the greatest, fighter who ever battled for a purse, a side bet or a ring of sharpers."[2]

The same article bemoaned the fact that some of Gans' fights were not always on the level and that he had been led astray by his long-time manager, Al Herford. Herford often instructed Joe to prop up fighters so that his bouts would last longer and occasionally forced him to "take a dive" and lose the bout so Hereford could collect on a wager. Even with a crooked manager, an often-hostile crowd and unscrupulous promoters that insisted on having Gans fight at unnaturally light weights, Joe Gans' record is remarkable: 158 wins (100 by knockout), twelve losses, twenty draws, and six no contests.

Joe was born in Baltimore, Maryland, in 1874 with the name, Joseph Butts. There is no record of his parents, and he was adopted by his foster mother, Maria Gant, whose name he was given. As a teenager he worked in a local market as an oyster "shucker" and began to fight locally in what were dubbed "battle royals" where three or more fighters, sometimes blindfolded, fought in the ring simultaneously.[3] He quickly

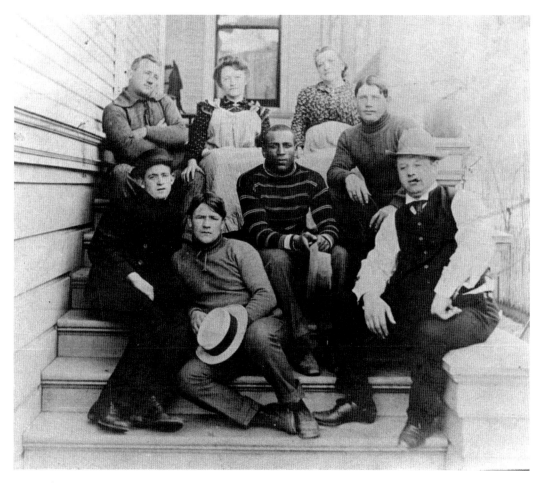

Champion Boxer Joe Gans, center, at Billy Shannon's Villa in San Rafael, 1908.

developed his boxing skills and Herford, recognizing his potential, signed him to a contract. An early newspaper article incorrectly spelled his last name with an "s" rather than a "t" and it stayed that way through his entire career.

His most famous fight was against the rugged "Battlin' Nelson" (Oscar Nielsen) in 1905 and is still considered one of the most brutal, hard-fought contests in boxing history. Gans was defending his title on Labor Day in Goldfield, Nevada, where temperature at ringside was over 100 degrees. The bout lasted three hours with Gans helping Nelson up several times after knocking him down. Gans won on a foul in the forty-second round called by the referee against Nelson for a low blow. With the winnings from this fight, Joe opened the Goldfield Hotel in Baltimore and what was termed a "black and tan music club" that secured his family's fortunes.[4]

Joe fought ten times in the Bay Area and often trained at Billy Shannon's Villa located at the end of 4th St. in San Rafael. Shannon's was a popular boxing club for both local and out-of-town fighters and was a favorite training site for Gans.

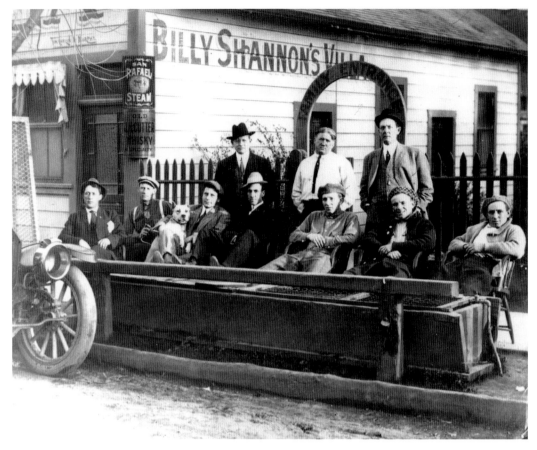

Boxers and trainers outside Billy Shannon's Villa in San Rafael, *c.* 1910.

In 1905, while he was preparing for a fight in San Francisco, Joe referred to the gym, hotel and restaurant as "home" and was quoted as saying,

This is the healthiest place that I ever saw. It is now winter but there is the grass, sunshine and flowers. The San Francisco smoke and fog never reach you. A few hours after a heavy rain the roads are dry, and a fellow can jog along them and never know that he is training. That is why I always train here.[5]

27
"Divine Sarah" Performs at San Quentin Prison

Through the years, there have been many performing artists who have given their time and talent to entertain the prisoners at San Quentin Prison. Notable acts include heavy-metal rock band Metallica, country-western star Johnny Cash, comedian Phyllis Diller, and crooner Frank Sinatra with the Count Basie Orchestra. However, one of the earliest performances at San Quentin by a major star goes all the way back to the second decade of the twentieth century when international stage and silent film actress, Sarah Bernhardt, took the stage at the "Big House."[1]

Near the end of the reform-minded progressive era, rehabilitation of prisoners was an emerging goal of the California Correctional System. It was thought that bringing art and culture to prisoners could have an ameliorating effect on the lives of the men and women serving time behind bars. In 1911, warden John Hoyle brought the 1910 Broadway play, *Alias Jimmy Valentine* to San Quentin: a tale of a reformed safe cracker who goes "straight" to stay out of jail and win the heart of the woman he loves. Two years later, internationally acclaimed stage actress, Sarah Bernhardt (pictured below in the tricorne hat and double-breasted jacket), having heard of the 1911 performance, arranged with California authorities and Warden Hoyle to come to Marin and perform at the prison. She chose to perform *A Christmas Night Under the Terror*, a play written by her son about the French Revolution in which prisoners are paroled in the final scene due to the passionate entreaties of one of the daughters of the condemned, played of course by Mme. Bernhardt.

She chose February 22, George Washington's birthday, for her visit, "…declaring it was one in which the French people took pride because of the intimate relations of Lafayette and Rochambeau with the first president of the nation."[2] The *San Francisco Call* newspaper reported that the prisoners built an open-air stage on one of their exercise yards and formed an orchestra to accompany the production. Nearly 2,000 inmates, including several women prisoners and men condemned to death were seated for the show when "…a pair of huge and massive doors of iron-barred oak were opened to admit the very modern six-cylinder automobile bearing Madame Bernhardt and her leading man M. Lou Tellengen."[3] In the photograph, Mr. Tellengen is standing to Ms.

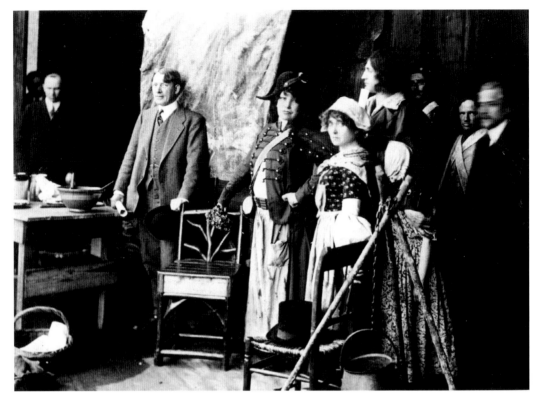

French actress, Sarah Bernhardt, center stage in tri-cornered hat, performing at San Quentin Prison, 1913. (*Photograph by Madison Devlin*)

Bernhardt's left and Warden Hoyle to her right. Mme. Bernhardt was supported by actors from her troupe and several prisoners who were given small roles in the drama.

After the thrilling conclusion of the performance and the thunderous applause of the audience, French-born prisoner George Corviseur, serving seven years on a Stockton, California, forgery conviction, read a heartfelt letter of thanks in both French and English from all the prisoners attending. It concluded with the following words:

Today, for one short hour, these walls of stone have vanished and, thanks to your marvelous personality and your enchanting art; we have been at perfect liberty in soul and mind, and captives only to the singular genius and incomparable art through which you have justly gained the title of "The Divine Sarah."[4]

28
The California Motion Picture Corporation: San Rafael Goes "Hollywood"

In 1914, just three years after East Coast motion picture companies began moving to Hollywood, San Rafael's Sun Valley neighborhood became the home to one of the premier movie-making studios of the young film industry. The California Motion Picture Corporation (CMPC) was the brainchild of Comstock mining heir, Herbert Payne, who wanted to make films to promote tourism and industry in California. He hired friend and San Francisco automobile dealer George Middleton to help him produce the films. The company built their state-of-the-art studio on land between today's Forbes and 5th Avenues and J and K Streets in San Rafael. They selected the site for its proximity to numerous natural environments in which to film, and its nearly year-round sunny climate—an absolute necessity before interior lighting technology had been developed.

In its early days, the studio produced a series of travelogue films for eastern and mid-western theater circuits titled, *The Golden Gate Weekly*. But auto-dealer George Middleton and his wife, Beatriz Michelena entertained greater aspirations. Beatriz was a beautiful opera *prima donna* on the San Francisco stage with immense star power. She and her husband recognized the emerging popularity and profitability of motion pictures and were soon producing, directing and acting in prominent feature-length films. They chose for their first "filmatization," a Bret Harte short story, *Salomy Jane's Kiss,* a western romance that was released as *Salomy Jane*.[1] The film was released in late 1914 to a limited, nationwide audience having first screened at the St. Francis Hotel.

Michelena's natural beauty and operatic acting experience gave her the tools to make the transition to silent film and, for a time, rival the popularity of silent film star Mary Pickford. Beatriz also performed her own stunts on horseback and in hazardous scenes in the films. She was nearly drowned when swimming a swollen, fast-moving river and twice was knocked unconscious for more than an hour, once, after a fall from her horse and another when accidently dropped by her leading man. In the next two years the studio released eight more films including *Mignon*, a story based on three Brett Hart poems; *The Lily of Poverty Flat*, a Bret Hart story filmed mostly in the Santa Cruz Mountains near Boulder Creek, *A Phyllis of the Sierras,* filmed along the Russian River

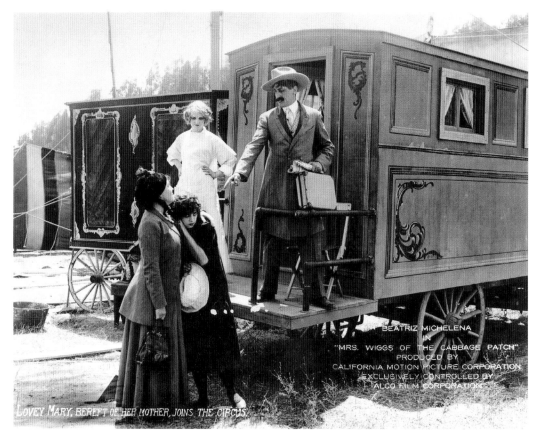

Production still from California Motion Picture Company's silent film, *Mrs. Wiggs of the Cabbage Patch*, starring Beatriz Michelena, 1914.

and *Mrs. Wiggs of the Cabbage Patch*, from a popular novel of the era, seen in the photo above.

The CMPC studio featured a large two-story building devoted to offices and dressing rooms, stables for horses and stagecoaches, a carpenter shop and prop storage warehouse, a film processing laboratory and vault and a cook's building that served as both the kitchen and lunchroom for employees. Most impressive, and quite unique for the era, was the large, glass-encased film stage that let in light, but not wind. In the first years of the silent film era, indoor lighting technology had not been developed and filming required plentiful sunlight. The CMPC's enclosed film stage allowed interior scenes to be filmed without the actors being plagued by gusts of wind that blew their clothing and hair or lightweight props such as tablecloths and curtains. Another innovation pioneered by the company was the filming of interior scenes at remote locations. The studio constructed the shell of buildings minus a roof and one side that were covered by white sheets and light diffusers so that interior filming could be done without traveling back to the studio.

California Motion Picture Company employees in front of the glass-enclosed film stage in San Rafael's Sun Valley neighborhood, *c.* 1915.

The studio's films received rave reviews for their authenticity of character, sets, wardrobe, and action sequences. However, the corporation could never cover the costs of their extravagant productions as they attempted to bypass the handful of film distributors that owned most of the nation's theater circuits and the studio was taken into bankruptcy in early 1917. After the bankruptcy, the Middletons purchased the corporation and produced three more westerns under the name, Beatriz Michelena Features. That company folded in 1920 and Beatriz and George Middleton divorced soon after. George went back to selling cars and Beatriz tried, unsuccessfully, to resurrect her operatic career. In 1942, she died at the relatively young age of fifty-two.

Tragically, the entire film stock made by the two studios perished in flames in 1931 when children playing with firecrackers set the San Rafael film vault on fire. It was not until an old nitrate copy of *Salomy Jane* turned up in Australia in 1996 that modern-day audiences were given the chance to see Michelena and the film that catapulted the California Motion Picture Corporation onto the national scene.

29

The San Rafael Municipal Baths: Home to Olympic Champion Eleanor Garatti

In the early decades of the twentieth century, the city of San Rafael owned one of the most modern and luxurious salt-water bathing facilities in the state of California. In 1914, The San Rafael Municipal Baths were built over the San Rafael Canal near the intersection of today's Lincoln Ave. and Second St., replacing the previous open-air baths constructed around the turn of the century. The large, mission-style building was funded by a $40,000 bond measure and managed by the town's trustees. It featured a 120 by 60-foot pool, that used filtered and heated canal water, a diving board and a 30-foot-high springboard. Roped off at one end was a smaller pool for children and those learning to swim. A 1915 *San Anselmo Herald* article reported:

> The big tank is in the middle of a vast, arched room with 118 dressing rooms situated on either side—one side for men and one side for women. In addition, there are 52 lockers for children. The tank contains when filled, 264,000 gallons of water kept at a temperature of 76 to 78 degrees. The water is filtered and passed through a coagulator, so it is absolutely pure.[1]

On the upper floor, a balcony surrounded the pool where spectators could watch the swimmers below and bathers could ride a slide down into the main pool. Harold Duffy was manager of the baths for decades and claimed that the 50 cent adult entrance fee and nominal cost for children was the lowest of any municipal pool in the Bay Area.

The baths were a center of community activity and aquatic fun well into the 1930s and became famous for being the pool that two-time Olympic gold medalist, Eleanor Garatti learned to swim in and perfect her stroke. Eleanor was a second-generation Italian American who was born on Belvedere Island and grew up within a few blocks of the San Rafael Municipal Baths. Garatti, just a teenager, rocketed to national and international fame during the 1920s as she repeatedly set world records in the 50- and 100-yard swimming sprints around the country. According to a 1927 *Sausalito News* article, Garatti, "carried off the honors" at the San Rafael pool appearing with two-time Olympic Champion and future film star Johnny Weissmuller.[2] Eleanor lowered her time in the 100-yard swim that day to a record 1:03.25.

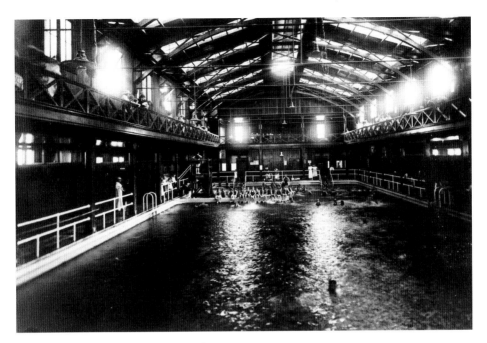

Interior of San Rafael Municipal Baths.

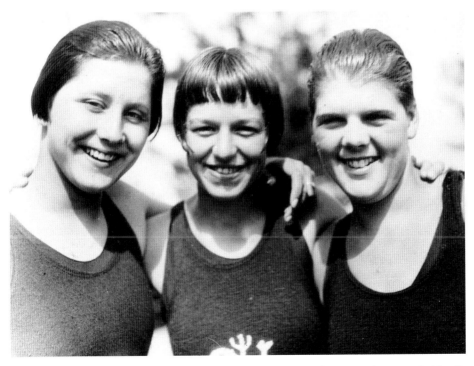

Eleanor Garatti, left, with competitors Hilda Curtis and Adrienne Gibson at Oakland's Idora Park swim meet, September 20, 1925.

Garatti's domination in the short-distance sprints earned her a spot on the 1928 U.S. Olympic swim team that travelled to Amsterdam where she won a silver medal in the individual 100-meter race and a gold medal as a member of the women's 4×100 relay team. Eleanor returned to San Rafael as a celebrated athlete and became a regular participant in swim meets around the country and as a luminary at many local fairs and events. She competed four years later in the 1932 Los Angeles Olympics, winning a bronze medal in the individual 100-meter race and repeating as a member of the gold-medal winning 4×100 relay team. Eleanor continued to compete after the Olympics before retiring from swimming, having married engineer Laurence Edward Saville and moving to San Francisco.

In the mid-1930s, during the Great Depression, the baths became a financial liability for the city and San Rafael leased the second-floor rooms to local veteran and citizen groups for meetings. The large main room was leased to the H.C. Little Burner Company, which covered the pool and converted the building into a factory for the manufacture of residential oil burners. On June 4, 1949, the historic building caught fire, started by a young, part-time janitor who lit some trash in an unvented ashcan that he thought was an incinerator. The historic old bathhouse went up in flames, endangering the nearby bus and railroad stations, before burning to the ground in less than an hour.

30
Midnight Serenades at "Chicken Point"

A picture can be worth a thousand words and sometimes leave us speechless. The lovely and serene image below, taken at sunset from Chicken Point, now Bayside Acres off San Pedro Road in San Rafael, is such a photograph. It was composed and photographed by one of the earliest female pioneer photographers, J. W. Carey. Relatively unknown, she established herself in the daguerreotype and ambrotype business with another female photographer, Amanda Genung, in Stockton in the 1850s and San Jose in the 1860s.

Chicken Point, according to a 1914 *Marin County Tocsin* article, was named after the area's chief industry of "poultry raising."[1] One of the first homes in the area, built in 1906 by John A. McNear and his son, Erskine, still stands at 121 Knight Drive. The McNears commissioned acclaimed Sonoma County architect Brainerd Jones to design the 10,000-square-foot home on a knoll overlooking what was then the family dairy farm. Years later, Chicken Point was developed for homes and renamed Bayside Acres. In the first decade of the twentieth century, San Rafael resident W. T. Ortman recalled renting a boat with ten young couples on a moonlit night and beaching the launch at Chicken Point. There, they were serenaded by one of their party singing from the cliff above. The couples then crossed the bay to Winehaven, a small town with one of the largest wineries in the world, on Point Molate in the East Bay.

> Sometimes at that hour of the night, the caretaker would be sound asleep in his bed. When we got him outside, we would dance around him—sing and play music until he was fairly well awake. After that, the dance pavilion was open and the snack-bar was unlocked. We feasted and danced until the sun came up.[2]

Though San Pedro Road was paved in 1934, Bayside Acres remained relatively undeveloped through the 1930s and 1940s with the area being popular for duck hunting and striped bass fishing. The large housing developments at Loch Lomond, Bayside Acres, and Glenwood were developed in the 1950s and much of the land in the surrounding area was annexed to the City of San Rafael in 1955. Homes were advertised from as low as $16,500 for three bedrooms and two baths up to $39,500 for

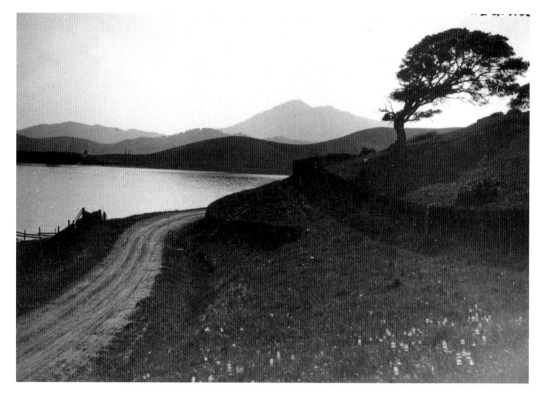

View of Mt. Tamalpais from Chicken Point in San Rafael, 1899. (*Photograph by J. W. Carey*)

four bedrooms and three baths. The first San Pedro School, built by McNear in 1904 for families working his brickyard and dairy, closed in 1950 and students were bussed to San Rafael. Several years later, San Pedro School opened just east of Townes Hill. Further development in the area surrounding Chicken Point has continued, unabated, to the present day. We cannot return to the past, but Ms. Carey's photograph allows us to pause for a moment and marvel at the beauty and tranquility that has attracted so many of us to call Marin County our home.

31

The Nine Lives of San Anselmo's "Sleepy Hollow"

The San Anselmo neighborhood of "Sleepy Hollow" was once part of the Mexican Land Grant, Rancho Cañada de Herrera ("valley of the blacksmiths"), which was first given to Presidio soldier Domingo Sais in 1839. In 1853, the land passed to his son Pedro who then leased the area to Harvey Butterfield. Butterfield built a home there and raised cattle for milking. As the ranch was a few miles up a dirt road from the main east–west trail, wagon drivers and riders referred to it as "The road to the old Butterfield Place," which eventually was shortened to "Butterfield Road."[1] In 1863, Pedro Sais sold the land to investors who planned to build a luxury hotel at the end of the road. However, the partners never realized their dreams and lost the land to foreclosure, though many of the large poplar and eucalyptus trees they planted still line the road today.

Anson P. Hotaling, the wealthy owner of Hotaling Liquors in San Francisco, bought the property in 1889 and leased some of the land to local dairyman, Frank Denez. In 1890, Anson's youngest son Richard, a member of the exclusive Bohemian Club and an amateur actor, built a large and elegant mansion at the end of the road that featured a grand staircase of imported Spanish cedar and an immense living room with a raised platform and theatrical balcony for the staging of plays. Richard also took over operation of the dairy and imported 200 Holstein cattle from Holland and named the area Sleepy Hollow after Washington Irving's literary masterpiece. The Hotaling family made a fortune providing whiskey and other potables to a generation of San Franciscans from their Jackson St. warehouse. The warehouse and all its contents miraculously survived the 1906 San Francisco Earthquake and Fire with the help of many volunteers aiding the overworked and undermanned city fire brigade. Over the first two days of the raging inferno, firefighters, army personnel and local citizens pumped sea water eleven blocks from the bay onto nearby buildings saving the warehouse and its flammable and precious stock.

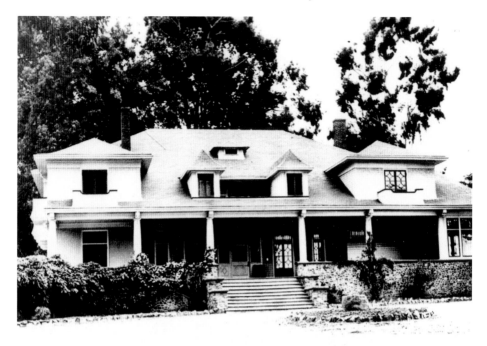

Sleepy Hollow Golf Course clubhouse, formerly the Hotaling family mansion, *c.* 1936.

Golfers "teeing off" at the Sleepy Hollow golf course, *c.* 1938.

Charles Field, a local writer and poet penned this now famous epigram about the incident:

> *If as they say, God spanked the town*
> *For being over frisky,*
> *Why did He burn His Churches down?*
> *And spare Hotaling's Whiskey.*[2]

Richard Hotaling eventually sold his cattle and 1,600 acres of Sleepy Hollow land to his friend, Sigmund Herzog of San Rafael, a successful businessman, property owner and banker. In 1910, Herzog established the first certified milk dairy in the United States that featured mechanical milking machines and a rigorous protocol of washing and cleaning the cattle, barns and equipment.

After a long, bitter court battle in the 1920s between Richard and his family, the land was sold to a Chicago Syndicate that hoped to build two golf courses and use the mansion as the clubhouse. Sigmund Herzog moved his Sleepy Hollow Dairy to Petaluma where it still survives today. The stock market crash of 1929 put an end to the golf course project and the land lay fallow for a few years. In 1935, investors George Keanel and H. A. Willard bought the mansion and surrounding land and built an 8,000-yard championship golf course converting the mansion into the popular, but short-lived Sleepy Hollow Clubhouse and Restaurant.

With the onset of World War II, water was diverted from the property to Hamilton Field and the Sleepy Hollow Golf Club passed into memory. For a time, the U.S. Army occupied part of the valley building a secret ammunition storage depot and installing two antiaircraft batteries. After the war, hundreds of homes were built in the area by Lang Realty which had purchased the land back in 1932. As a promotional tool, the company named the streets after characters and locations in Washington Irving's *The Legend of Sleepy Hollow*.

A. G. Raisch, a local paving contractor, and his wife, Katherine, purchased the estate and remodeled and modernized the old mansion. News items of the era reported on the couple hosting large, lavish parties, benefits, BBQs, and equestrian competitions at their home and in the nearby stables. It was not uncommon for the events to have over 500 attendees. Eventually, they moved to San Rafael and the home was closed and fell into disrepair. In 1957, the abandoned Hotaling Mansion was destroyed in a mysterious fire that was blamed on arsonists. A year later, the Dominican Sisters of San Rafael purchased the old Hotaling estate and construction began on San Domenico School in the summer of 1964. By the fall of 1966, students began attending the school that lay at the end of "the road to the old Butterfield Place" in Sleepy Hollow.

32

Next Stop, Lansdale Station!

When driving west between San Anselmo and Fairfax, the route along Center Blvd. is often less crowded and hectic than traversing the main artery of Sir Francis Drake Blvd. The ruler-straight, raised roadbed follows the old Northwestern Pacific Railroad (NWP) line between the two towns. In 1905, the western portion of San Anselmo known as the Bush Tract was developed for housing and two rail stations were built to serve the growing communities. Yolanda Station was built in 1905 where today's Redwood Dr. and Saunders Ave. cross Center Blvd. near Archie Williams High School. Three years later, Lansdale Station, originally named Bush Station, was built further west, and renamed after Philip Lansdale, a partner in the real estate firm that developed the area. Although not well-known, the neighborhood in and around this intersection is still referred to as Lansdale Station.

When the tracks were laid, there was a wooden train trestle built over San Anselmo Creek at the station. There was also a wooden bridge crossing over the creek that was a known hangout for transients and local youth, especially in summer. Residents complained to city officials that it was, "a rendezvous for disorderly young people who were often insulting to unoffending by-passers."[1] The same 1913 *San Anselmo Herald* article highlighted the local resident's successful opposition to Lansdale Station grocer, I. J. Hall's application for a liquor license claiming that under, "the present conditions, with whiskey thrown in, it would render the neighborhood intolerable."[2] Mr. Hall was one of many business owners who ran establishments at Lansdale Station through the years. Other markets flourished there, owned by C. J. Dykes, the Thompkins Brothers, and P. J Cullen. Marin newspapers of the era also ran advertisements for a local barber shop, meat market, shoe-repair shop, and Coppa's Grove Hotel & Restaurant. Coppa's Grove was owned and operated by Italian immigrants Joseph and Elizabeth Coppa who soon moved their restaurant from Lansdale Station to San Rafael having opened an earlier Coppa's Restaurant in San Francisco where it was known for its fine food and bohemian atmosphere.

At the height of rail travel, the trains running through Lansdale Station from San Francisco to Fairfax were scheduled every half hour during the day and the entire trip took only one hour, including the Ferry ride from Sausalito. It would be hard to

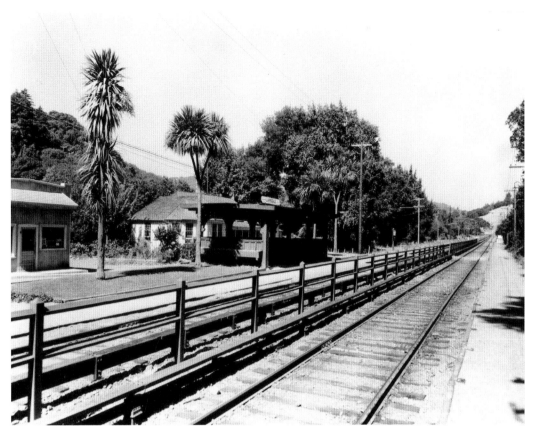

San Anselmo's Landsdale train station. *c.* 1935. Today, Center Boulevard follows the old railroad line.

beat that time with today's traffic bottlenecks! By the late 1930s, the NWP was losing money as the automobile became more popular and the opening of the Golden Gate Bridge made a ferry transfer unnecessary. The last interurban train ran through Marin and Lansdale Station in February 1941 bringing an end to nearly seventy years of fast, efficient and inexpensive rail service.

33
Louise Arner Boyd, "The World's Most Enterprising Woman Explorer"

Though nearly forgotten in history, Louise Arner Boyd's intrepid spirit and life achievements border on the legendary. She was a self-taught geographer, polar explorer, photographer, and author who spurned nearly every expectation set for a woman born in the late nineteenth century. Louise was born on September 16, 1887, to John and Louise Boyd who made their fortune in the Bodie Gold Mine bonanza. Like so many wealthy families of the era, the Boyd's split time between two homes; Maple Lawn in San Rafael, and their livestock farm of more than 6000 acres on the slopes of Mt. Diablo. As a child, Louise developed an early love of the great outdoors, chasing after her two older brothers, Seth, and John. When she was just a teenager, both her brothers died within a year of one another from heart disease brought on by complications from childhood rheumatic fever. Her parents were devastated and in 1905, they donated Boyd Park with its ornate, Queen Anne gatehouse to the City of San Rafael in memory of their sons.

After these tragedies, Louise chose a life of adventure and exploration rather than settling down to marriage and raising a family. She traveled widely with her parents learning the art of photography and in her twenties became an officer and manager of her father's business concerns. Always the intrepid traveler, Louise took a train to Buffalo, N.Y., in 1919, purchased a touring car, and motored across the United States with her chauffeur at a time when there was no highway system, and most roads outside of cities were gravel or dirt. This would be the first of many coast-to-coast trips she would take and could be one of the first cross-country automobile trips completed by a woman. Upon her parent's death in 1920, Louise immediately set out on a tour of World War I battlefields, photographing and filling her diary with descriptions of the bombed-out cities, cathedrals, and landscapes that "were bare of every tree."[1] She was presented to the king and queen of England in 1925, one of the few unmarried, American women to have that honor. She became enamored of the Arctic on a pleasure cruise in 1924 and returned in 1926 chartering a ship for a hunting and filming trip to the Arctic accompanied by her friends, the count and countess of Ribadavia.

Over the next decade she would finance and lead six scientific expeditions to Greenland and the Arctic accompanied by numerous geographers, hydrographers, botanists, and scientists.

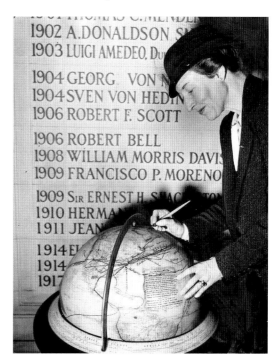

1902 A. DONALDSON S
1903 LUIGI AMEDEO, Du
1904 GEORG VON N
1904 SVEN VON HEDI
1906 ROBERT F. SCOTT
1906 ROBERT BELL
1908 WILLIAM MORRIS DAVI
1909 FRANCISCO P. MORENO
1909 Sir ERNEST H. S
1910 HERM
1911 JEAN
1914 E
1914
1917

Louise Arner Boyd signing the Explorer's Globe after receiving the Cullum Medal from the American Geographical Society, 1938.

She photographed and surveyed unexplored glaciers, valleys and mountain ranges while collecting plant specimens under the direction of Alice Eastwood, the botanical curator of the California Academy of Sciences. Louise mapped and photographed vast areas of Greenland that led to many discoveries of unknown glaciers, undersea mountain ranges, and collected valuable information on Arctic Ocean currents and temperatures. Under the auspices of the AGS, Louise published two books documenting her expeditions: *The Fjord Region of East Greenland* and *The Coast of Northeast Greenland*. For her leadership and scientific work, Ms. Boyd was awarded the prestigious Cullum Medal in 1938 by the American Geographical Society (AGS). In praise of Louise, pictured above signing the AGS globe, her award read, "The dauntless leader of scientific expeditions into the Arctic, she has captured the spirit of the polar world in photographs of rare beauty."[2]

Louise also represented the United States at the 1934 International Geographical Conference in Poland. Although she was to deliver a lecture on her 1931 and 1933 expeditions to northeast Greenland and report back on the Congress, Louise also made additional plans of her own. She understood that the Polish nation was soon to experience substantial change after having as she wrote, "vanished from the maps of Europe for a century and a quarter" until being recreated after World War I.[3] Her plans were to travel to all corners of the nation making, "a photographic record of the rural life of the country and to obtain, before it was too late, views of things that are characteristic today but may be gone tomorrow."[4] Louise little realized how prophetic those words would be as Poland would soon be overrun by German armies and fall under the oppressive yoke of Stalinist Russia within a few years. Her photographs and experiences from that trip were published in another AGS book, *Polish Countrysides*.

During World War II Louise financed an expedition to the arctic, secretly working for the War Department, to help the government understand and establish long-distance radio transmission stations for ships and submarines crossing the north Atlantic. She kept offices in Washington, D.C., and worked, off and on, for the Bureau of Standards from 1941–1943 for the nominal sum of $1 per year. In 1949, she received a certificate of appreciation from the armed services as a technical expert and consultant for supplying critical geographic knowledge gathered during her many arctic expeditions.

Ms. Boyd continued traveling the world in her later years, visiting Europe, Asia, and the Alaskan wilderness. In 1955, Louise realized a life-long dream when she chartered a DC-4 airplane and flew over the North Pole, the first woman to accomplish that feat. Regrettably, after decades of financing her own expeditions along with her penchant for living in grand style, Louise's finances were exhausted, and she was forced to sell her family's San Rafael home. She continued working to catalog and organize her papers and photographs, most of which are now divided between The Marin History Museum and the University of Wisconsin's, American Geographical Society Library. Louise died two days shy of her eighty-fifth birthday, almost penniless. Though her entire family is buried here in Marin at Mt. Tamalpais cemetery, Louise, true to her nature, was cremated and arranged for her ashes to be scattered over Point Barrow, Alaska, in one last expedition to her beloved Arctic. Geography historian J. K. Wright summed up Boyd's legacy when he wrote that Louise was "the world's most enterprising woman explorer."[5]

Louise Arner Boyd and crew members on board the Effie M. Morrissey during her 1941 expedition for the U.S. government.

34

Jacob Albert's El Camino Theater: San Rafael's Second Movie Palace

Today, when walking or driving down Fourth St. in San Rafael, visitors can still see tangible touchstones to the city's past, such as the Albert Building, Marelli Brothers Shoe Repairing, and, of course, the Rafael Theater. However, the Rafael Theater (originally named the Orpheus) was not the only luxurious movie palace in town. Two blocks down Fourth Street, the El Camino Theatre also welcomed movie-goers into its plush interior to suspend their disbelief for a few hours and enjoy the latest Hollywood fare. It was, according to a 1928 *Napa Register* newspaper article, "Jacob Albert's new half-million-dollar theater … the handsome new show house is in the way of a gift to the people of San Rafael."[1] Jacob Albert came to Marin from Lithuania in 1883 with his wife, and not much else, and became a leading citizen and entrepreneur in the North Bay. He built San Rafael's first high-rise, the Albert Building in 1930, Albert Park, which he donated to the city, the El Camino Theatre and Albert's Department Store which was eventually sold to Macy's.

The El Camino Theater was designed and built by the architectural firm of Reid & Reid who were also responsible for such California landmarks as the Fairmont Hotel, San Diego's Coronado Hotel, the Grand Lake Theater in Oakland, and the original Cliff House. It was of Spanish Gothic design with ornate exterior embellishments and a nearly four-story central tower. The interior featured lush velvets of red and gold with a double staircase beckoning guests to the upper loge seating. Theater goers could also order delicious, toasted sandwiches from Sausalito caterer and café owner John Carlisle, who opened a second sandwich shop in the lobby of the theater. For many years it was part of the large Blumenfeld chain of theaters that included the Orpheus/Rafael, San Anselmo's Tamalpais Theater, the Lark in Larkspur, the Fairfax Theater, and the Gate and Marin theaters in Sausalito. After a 1937 fire and remodel at the nearby Orpheus, which then changed names to the Rafael, the El Camino began to run fewer first-run movies and was often the site of local events such as beauty contests, fundraisers, chamber orchestra performances, and as advertised in the photograph, Sunday Night Double Bingo!

The movies playing at the time the photograph was taken were both re-released in 1950 from earlier World War II versions and set a reasonable date for the photograph.

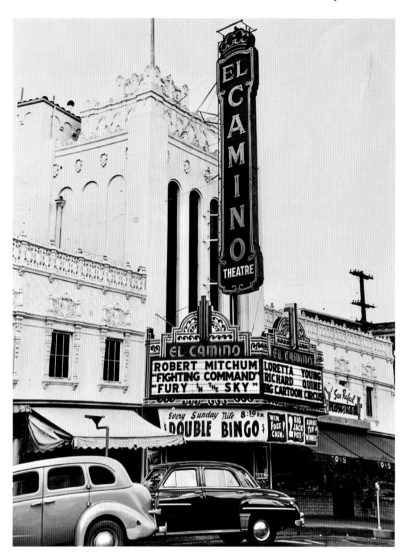

San Rafael's
El Camino
Theater, 1950.

Robert Mitchum's, *Fighting Command* was originally titled, *We've Never Been Licked* and told the story of Texas A&M military cadets and Japanese spies. Loretta Young's *Fury in the Sky* first ran as *Ladies in the Sky* and recounted the real-life experiences of the Women's Auxiliary Ferrying Squadron (WAFS). These brave women flew military fighters and bombers from their factories of origin to military bases throughout the United States.

In 1942, Jacob Albert built his department store next to the theater which remained in business until both buildings were sold to Macy's in 1952. The Macy's chain demolished much of the theater and expanded its store into the space leaving the Rafael Theater as San Rafael's only downtown movie palace.

35

Bronc Busting, Calf Roping, and Chariot Races at the Fairfax Rodeo

The Town of Fairfax is known as a bicycling mecca and a community that embraces progressive politics and alternative lifestyles. In the not-so-distant past, it was also the site of a rodeo that attracted thousands of spectators and hundreds of participants annually from the mid-1940s into the late 1960s. The rodeo was hosted at the Circle V Ranch, also known as the Smith Family Ranch in Baywood Canyon at the foot of White's Hill. The Smith family also owned over 800 acres north of San Rafael where older brothers Sam and Zeke operated a dairy, a county dump and a hog farm lending their name to today's Smith Ranch Road. Ed Smith, the son of Sam Smith, ran a dairy at the Circle V ranch in Fairfax and he and his uncle Zeke were both members of the Marin County Sherriff's Posse Roping Club which hosted the Fairfax Rodeo for its first fifteen years.

Articles in local papers described the "rip-snorting" action as both cowboys and cowgirls competed in contests of bronc busting, bull riding, calf and steer roping, wild-horse races, bulldogging, Ben Hur style chariot races, barrel racing, goat tying, and horse-cutting events.[1] Every year, a rodeo queen was chosen from entries sponsored by local stables and merchants who led the opening day Grand Entry parade. Competitions were held in the large outdoor ring and a smaller indoor ring on the property. There was seating for 4000 spectators and participants came from as far away as Walla Walla, Washington, and Bend, Oregon, to compete for prizes. The ranch was also the site of three-man, or Hawaiian, polo matches between Marin and other Bay Area teams.

After the deaths of the older Smith brothers, Sam and Zeke, in 1954 and 1955, the San Rafael Kiwanis Club hosted the rodeo through 1969 with proceeds benefitting many local charities. Along with the annual rodeo, the Circle V Ranch also hosted 4-H riding and show events, polo matches for Bay Area clubs, and offered stabling services and riding lessons for more than thirty years.

In 1971, Marin County planning commissioners rezoned the ranch land from agricultural to resort-commercial and planned residential, which allowed development of the property for mixed uses. The main parcel was sold in 1974 to Jack Farnar who developed the site and renamed it The Baywood Riding and Tennis Club. In 2000, the property was sold again and became the Baywood Equestrian Center where today the outdoor riding ring still bears the Circle V logo.

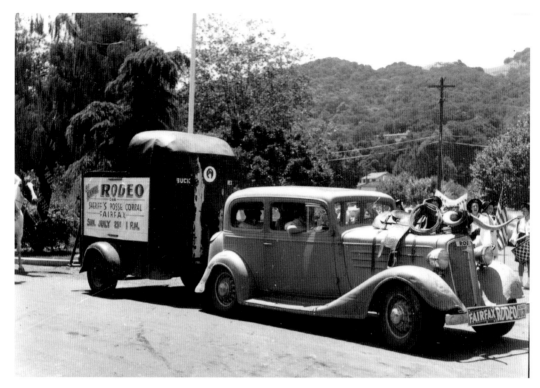

Promotional vehicle for the third annual Fairfax Rodeo, 1950.

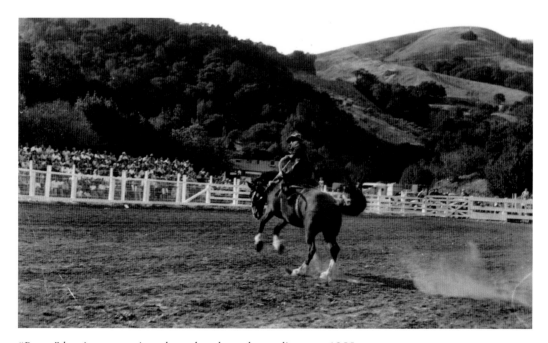

"Bronc" busting competitor cheered on by rodeo audience, *c.* 1955

36
Archie Williams:
American Hero and Marin Icon

Archie Williams, born and bred in the East Bay, lived a life full of great accomplishments while dedicating himself to the education and personal growth of others. Williams was an Olympic gold medalist, a flight instructor for the famous Tuskegee Airmen of World War II, a lieutenant colonel in the air force and a teacher, coach, and educator at Sir Francis Drake High School in San Anselmo, California for more than twenty years. With the recent renaming of Drake High to Archie Williams High School, his legacy will be celebrated and kept alive for generations to come.

Mr. Williams was born in Oakland in 1915, at the height of America's Jim Crow era. At that time, African Americans were denied most civil rights and opportunities, while often shouldering the fear of racial violence. In that atmosphere, Williams never wavered in his desire to succeed and his determination to get an education. His family lived on Telegraph Avenue on the border of Berkeley and Oakland. As a young child, his parents, Wadsworth and Lillian, ran a grocery store and rented rooms to U.C. Berkeley students. His father died when Archie was ten and his mother and grandmother, Frannie Wall, ran a home for local children, including many orphans. Frannie was well-known throughout the East Bay as a social activist and was a good friend of educator and civil rights leader Mary McCloud Bethune. As a child, Archie was always intrigued with airplanes and flight and dreamed of one day becoming a pilot. As a teenager, he won a model-airplane building contest that was sponsored by the *Oakland Tribune* newspaper. In a 1992 interview, Williams recalled how he could see the distant Campanile Tower at U.C. Berkeley from his parent's front yard and that he was determined to, one day, earn an engineering degree from Cal. Though Archie grew up in a relatively safe, integrated neighborhood, he also remembered being unable to join the Boy Scouts with his white friends as well as the signs at the nearby Idora Swim Park pool that read "No Blacks Allowed."

While attending University High School in Oakland, Williams ran track, mostly for fun, but did get his name in the local papers after winning some quarter-mile races. After high school, he and a friend decided to enroll at San Mateo Junior College which was free to attend. Within a short time, Archie was taking advanced math classes and getting

Archie Williams High School gymnasium. (*Photograph by Scott Fletcher*)

good grades. He joined the track team coached by Tex Byrd who helped Archie improve his running skills while encouraging him to study and get the grades he would need to attend Berkeley. Although he won the junior college conference in his distance, when he transferred to Cal in the fall of 1935, he was still relatively unknown.

As a sophomore, Archie took courses to earn his degree and joined the track team. His coach was the respected Brutus Kerr Hamilton, under whose tutelage Williams was soon posting record times in 400-meter races. At the 1936 NCAA finals in Chicago, Archie set a new world record of 46.1 seconds. This earned him an automatic berth at the Olympic Qualifying Meet in New York City. He was accompanied by Hamilton, who was an assistant coach for the 1936 Olympic team and his teammate, Bob Clark, who would win the Silver Medal in the decathlon later that summer. Archie finished first at the trials and was soon on a boat to Europe, the Olympics and athletic fame.

At the Olympics in Berlin, Williams and his African American teammates were very popular. He recalled that his German competitors, and the Berlin residents, were friendly toward the black athletes, approaching them on the street for autographs, and inviting them to their homes to meet their families. On the day of his race, Williams knew that his fiercest competition was Great Britain's Godfrey Brown. When the starter's pistol cracked, Archie, as usual, was near the back of the pack. But just like he had done all year, Williams began running down his competitors until he was in the lead going into

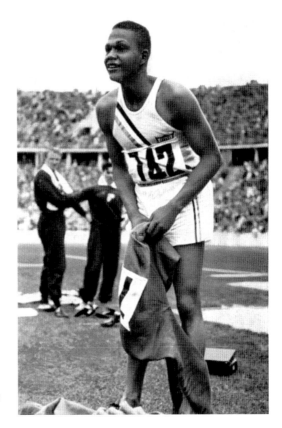

1936 Berlin Olympic gold medalist, Archie Williams.

the final turn. It looked like a runaway, until Gordon Brown began a last, desperate sprint to catch Williams. Just before the finish line, Archie summoned a little extra from his lean, athletic frame and held off Brown to win the gold medal with a winning time of 46.5 seconds.

The 1936 Olympics are still remembered for the success of Jessie Owens, Ralph Metcalfe and many of the black athletes winning gold and disproving Adolf Hitler's boast of the German "master race." Following the Olympic Games, Williams and other athletes went on a month-long track and field tour in neighboring European countries. In a race in Sweden, Archie injured a hamstring which kept him out of subsequent races and would eventually end his career as a runner.

When Williams arrived back in the Bay Area he was honored with a parade in Oakland and a large reception on the Berkeley campus. When asked about the treatment he received while at the Olympics, Williams' response was always, "Well, over there at least we didn't have to ride in the back of the bus."[1] He returned to Cal and earned his mechanical engineering degree in 1939. He then enrolled in the Civilian Pilot Training program to earn his pilot's license. With that training, Archie headed south to Tuskegee, Alabama, to teach civilian students to fly. While there, he remembered Eleanor Roosevelt visiting and using her influence to set up a military training program for pilots that would eventually become the famed Tuskegee Airmen. With the onset of

World War II, Williams enlisted in the Army Air Corps and attended UCLA for training in meteorology. He transferred back to Tuskegee as a second lieutenant where he taught meteorology and Intro to Flying to the all-black, 99th Pursuit Squadron, a segregated unit of the Army Air Corps. Archie would later earn another degree in aeronautical engineering from the Air Force Institute of Technology and would serve in the Air Weather Service for the next twenty years including a tour of duty during the Korean War.

Before retiring from military service in 1964 as a lieutenant colonel, Williams completed coursework at U.C. Riverside for his teaching credential. With encouragement from a former Cal teammate who was a superintendent with the Marin County public schools, Archie was hired to teach mathematics at Sir Francis Drake High School which opened in 1951. He also coached track and field and eventually, computer science. After more than twenty years in the classroom, Williams retired in 1987 and passed away in 1993. He is buried in the San Francisco Presidio, next to his grandfather, a veteran of the Spanish–American War. Archie is remembered as a dedicated, caring teacher whose classroom was open from 7:30 a.m. until 5 p.m. so he could teach, tutor, counsel, and help students to reach their full potential. Though his life was full of great personal achievement, it was his teaching that was most important to Williams. With the recent renaming of the school to Archie Williams High School, the community has chosen wisely to honor the legacy of a true American and Bay Area hero.

37

Early Mountaintop Hospitality

For thousands of years, a trail has led over Mt. Tamalpais from central Marin to the Bolinas lagoon. The original trail was used by the inland Miwok tribes to gain access to their coastal fishing grounds and for indigenous groups to visit and trade with one another. In the mid-to-late nineteenth century, early settlers used the trail for much the same purpose. But the steep, rugged terrain was not conducive to people traveling over the mountain or for transporting goods to Bolinas where they could be shipped to San Francisco. The towns of Bolinas and Willow Camp (later renamed Stinson Beach) were fast becoming popular spots for vacationers and campers and there were only a few routes that connected Central Marin with these coastal towns. All of them involved at least two means of transport, either a train and stagecoach ride or a stagecoach and launch or ferry boat trip. In 1877, the Marin County Supervisors approved funds to widen and improve the old trail over the Bolinas ridge and the contract was awarded to Jesse Colwell and J. H. Wilkins of San Rafael.

The contractors completed the road within a year using Chinese workers who were paid $1.25 per day to carve a road up over the Bolinas ridge and then down Cataract Canyon to Lagunitas Creek and Ross. A year later, Henry Gibson started the first stagecoach service from San Rafael to Bolinas, a trip that took three hours and cost $1.50. At the halfway point, just west of today's intersection of Ridgecrest Blvd and the Bolinas to Fairfax Road, C. F. Larsen and his wife opened the Summit House. The rustic, but charming guesthouse offered refreshments to passengers and day visitors and lodging for overnight guests who wished to enjoy the local hiking, hunting, and fishing. The Larsens advertised the Summit House as commanding "a beautiful view of the ocean" with a "first-class table" and "unsurpassed accommodations for $1.50 to $2.00 a day or $8.00 to $10.00 per week."[1] Mrs. Larsen gave birth to a daughter up on the mountain in April 1892 and the birth was announced in the *Marin County Tocsin* newspaper later that month.

In 1894, the family sold 20 acres and the house for $5,000.00 and took over management of the Cosmopolitan Hotel in San Rafael, changing the name to Larsen's Villa. Greek-born Constantine De Sella purchased the Summit House that year with a

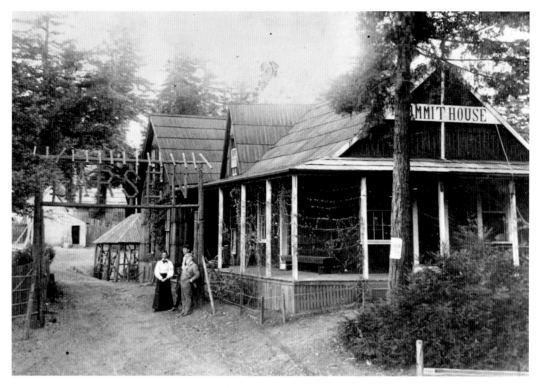

Summit House Inn high atop Mt. Tamalpais, *c.* 1890.

partner and ran it as a popular lodge and tavern. De Sella was celebrated as a great chef, an excellent host, and a friend to all who stopped at the lodge. He made his culinary reputation as the primary chef on the ferries that ran between San Francisco and Sausalito for many years. As he was known to be a dapper dresser and wore a long white beard and hair, it is more than likely that he is the person standing next to the Larsen couple in the photograph above. In September 1904, a fire broke out on the Bolinas ridge, destroying the Summit House and many ranches down towards the ocean. According to local news articles, Constantine De Sella barely escaped the flames and lost everything. The Summit House was rebuilt under new management and remained a thriving establishment and favored gathering spot for hiking organizations like the Sierra and Romany Clubs. The Summit House closed its doors in 1941, eventually succumbing to flames for the second and final time in 1945.

38

"The Play's the Thing" and It's Atop Mt. Tamalpais

The inspiration for putting on a play high atop Mt. Tamalpais is believed to have originated in 1912 when three hikers, Garnet Holme, John C. Catlin, and Richard Festus "Dad" O'Rourke, stopped to rest by a large outcrop of rock near the summit of the mountain. Catlin was a prominent San Francisco lawyer, O'Rourke, "a legendary outdoorsman" and Holme, a theater director, playwright and UC Berkeley drama coach.[1] Holme, taking in the dramatic view of the Bay is reputed to have exclaimed, "What a perfect setting for an outdoor theatre."[2]

The first play was performed the next year on May 4, 1913. It was a production of the ancient miracle play, *Abraham and Isaac*, directed by Holme. Scenes from Shakespeare's *Twelfth Night* were also performed that first year. More than 1,200 people attended the play, paying $1 apiece for tickets. At the time, there were only two ways to get to the natural amphitheater atop the mountain. Hikers could walk the entire six miles from Mill Valley up the trails to the theater or catch a ride on Sidney Cushing's Mount Tamalpais & Muir Woods Railway to the West Point Inn. From there it was a short mile and a half walk. After the play, the intrepid could walk back down the mountain while most playgoers rode the gravity cars of the railway, dubbed "The Crookedest Railroad in the World," back to Mill Valley.

The following year, William Kent, owner of the land, deeded the site to the newly formed Mountain Play Association with Caitlin, O'Rourke and Kent serving as its first officers. In the early years, traditional plays such as *Peer Gynt, Tamalpa, Rough n' Ready, Rip Van Winkle* and *Robin Hood* were performed every few years. Outdoor theater productions were quite popular in the early twentieth century and many cities and towns celebrated their local history and legends in similar venues. What makes Marin's Mountain Play so special is that it has lasted for more than 108 years.

In 1936, the land was donated to the California State Parks system and work began on a 4,000-seat, natural stone amphitheater built by the Depression-era Civilian Conservation Corp. That amphitheater, named after Sidney B. Cushing, founder and president of the Mill Valley & Mt. Tamalpais Scenic Railway, still serves as seating for Mountain Play audiences today. During World War II, the Mountain Play was not performed for three years from 1942–1945.

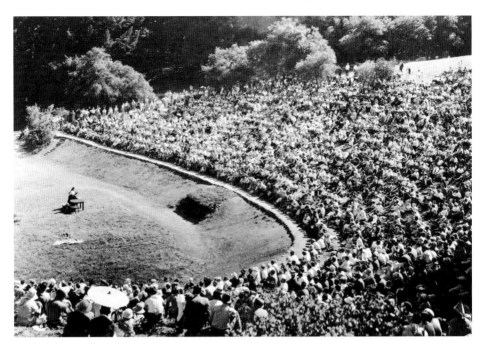

1933 Mountain Play production of The *Daughter of Jorio* at the Sidney Cushing Amphitheater atop Mt. Tamalpais.

Sidney Cushing Amphitheater built by the Depression-era Civilian Conservation Corps, 1937.

By the late 1960s, smaller and smaller audiences were attending the Mountain Play and it became clear to organizers that a change in the artistic programming was necessary. Starting in the late 1970s, Broadway-style musicals became the yearly norm with performances of *Annie Get Your Gun, Oklahoma, Peter Pan, The Music Man, Grease*, and *The Sound of Music*, "resulting in a financial revival and stunning artistic achievements."[3] Despite the recent cancellations of performances due to the pandemic, the Mountain Play is still very much alive and a popular annual tradition for theater lovers of Marin County and the entire Bay Area.

39

Ridgecrest Boulevard Toll Road: Gateway to Marin's Scenic Playground!

In big, bold print, a 1925 *Sausalito News* item announced, "At Your Very Door, California's Newest and Most Scenic Motor Road," enticing motorists to ascend to the top of Mt. Tamalpais, the "guardian of the Golden Gate."[1, 2] The Ridgecrest Boulevard Toll Road was the centerpiece of an ambitious countywide effort to link Bay Area drivers to the scenic views and magnificent panoramas from atop the mountain. The concept of creating such a road was first discussed at a Central Marin Chamber of Commerce meeting at the Tamalpais Tavern in 1922. Chamber members were so impressed with the lovely nighttime scenery that they believed an automobile road—open day or night—would be an attraction that all Bay Area residents would enjoy. The Ridgecrest Toll Road Company was soon incorporated by civic and business leaders M. H. Ballou, Thomas Kent, William Deysher, Thomas Boyd, and Fred Dickson to finance the roadwork, charge tolls, and reap any profits.

Construction began in late 1922 and by 1925 all the sections of roadway were completed so motorists could drive what was called, "The Circle Tour," in less than four hours.[3] The roadways, composed of compacted crushed rock, were engineered to be 20–24 feet wide with no more than an 11-percent grade. The original tolls were set at $1 per vehicle with two passengers and 25 cents extra for each passenger up to five. The road was also to have 15-foot cleared shoulders to help prevent fires and give fire crews the ability to traverse the mountain easily.

In the first couple of years, drivers arriving on the ferry from San Francisco were directed to take Redwood Highway from Sausalito to the San Anselmo Junction. Continuing west to Fairfax, motorists turned onto Bolinas Avenue and up to the Alpine Dam where the Toll Road started. Motorists could then drive seven miles along Bolinas Ridge to Rock Springs and up to the summit of Mt. Tamalpais. Automobiles could then descend to the Bolinas Lagoon, head south to Stinson Beach, and east to Redwood Highway, returning to Sausalito and the ferry. Within a few years, alternate toll roads were added that connected to Muir Woods from Stinson Beach and eventually a route directly from Mill Valley to Panoramic Highway and the ridge route.

In 1942, with the United States' entry into World War II, the Ridgecrest Boulevard Toll Road Company was given notice in federal court that the road would be leased to

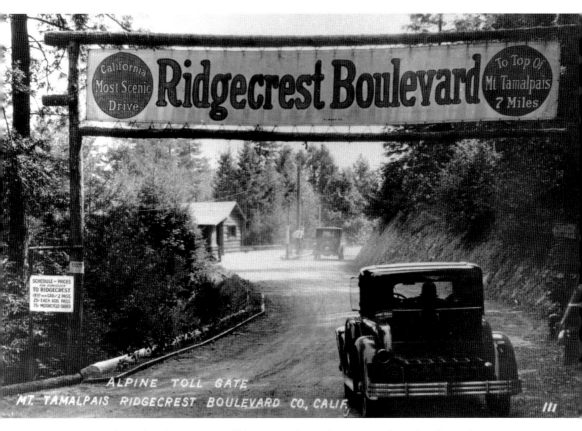

Cars approaching the Alpine Dam toll house on the Ridgecrest Boulevard Toll Road, *c.* 1925.

the U.S. Army on a yearly basis and tolls would no longer be charged. After the war, the California State Parks Commission purchased the road and 25 acres at the summit from the heirs of the Kent Family. Looking back, the toll road's success in opening the Mt. Tamalpais watershed and coastal beaches to both residents and visitors was instrumental in the development of Marin County as San Francisco's scenic "playground."[4]

40

Marin's Cross-Country, Over the Mountain Dipsea Race

In the photograph on the following page, the winner is … number 29, Paul Chirone of San Anselmo! The world famous Dipsea Race, initially run from downtown Mill Valley over Mt. Tamalpais to Stinson Beach in 1905, was the first organized trail race of its kind and has been run nearly every year since. The 116-year-old competition had its origins in a bet made by two San Francisco Olympic Club members, Alfons Coney and Charles Boas. Both Coney and Boas were avid hikers and frequent guests at the Dipsea Inn at Willow Camp, the early name for Stinson Beach. Built in 1904, the inn was located on the sand bar that protects Bolinas Lagoon, and was owned by influential county residents, William Kent and Sydney Cushing. Coney and Boas challenged each other to a friendly race from downtown Mill Valley to the Inn, with Coney being declared the winner. The following year, Olympic Club members organized the first official race with over 100 contestants competing. The origin of the name, Dipsea, was first applied to Kent and Cushing's Inn but is lost in history. The two competing theories are that visitors to the Inn were encouraged to take a dip in the sea or that the route to get to the Inn required travelers to dip down Mt. Tamalpais to the sea.

The inaugural race began at the Mill Valley train depot and climbed 7.4 miles over the mountain, ending with a long, tiring run on the sand spit near the Inn. Runners were given head-starts, or handicaps, based on their individual times in other races while more experienced, professional racers started last. A seventeen-year-old, J. G. Hassard of Oakland High School, crossed the finish line first in a driving rain, benefitting from a ten-minute head start. The fastest time, one hour and four minutes, was run by C. Connolly who arrived just two minutes after Hassard. By 1907, the grueling last dash over the sand was removed from the course and contestants finished the race on the main road through Willow Camp.

The competition was run exclusively by men in its early years, but in 1918 a Dipsea "Hike" was organized for women by Olympic Club member and women's sports advocate, George James. The women's Dipsea race was called a "hike" rather than a race to placate the Amateur Athletic Union which frowned on women competing in most sports. The first winner was nineteen-year-old Edith Hickman, who finished in one hour and eighteen minutes, six full minutes ahead of her nearest competitor. The

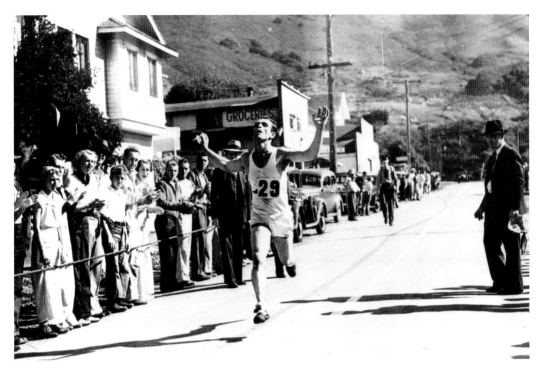

1937 Dipsea race winner, Paul Chirone. (*Photograph by Wesley Swadley*)

Dipsea Hike grew in popularity; there were over 600 contestants in its third year, and even outdistanced the men's race in interest with thousands of spectators lining the finish line. Unfortunately, after the 1922 race, patronizing chauvinism won the day and the event was cancelled as "Local churches and physicians were objecting to the competitors' fashion ('hiking costumes') and 'undue stress on women's bodies'… with health concerns that the competitors were compromising their reproductive systems."[1]

It was not until the 1950s that women began running the race again and not until 1971 that they were allowed to be official entrants. Since that time, contestants of all ages and gender have run the race. The unique age-handicapping system has produced both male and female first place finishers from eight years old to seventy.

And now, back to Paul Chirone. Paul was a twenty-three-year-old who had previously run on the Tamalpais High track team without much fanfare or success. He finished twenty-fifth out of thirty-five runners in the 1936 Dipsea Race. But on the night before the 1937 race, Chirone met Norman Bright, an Olympic Trials runner and recent winner of San Francisco's Cross City run (now the Bay to Breakers). Chirone picked up some tips from Bright about the course and how to run it. Although Bright would finish with the best time, forty-seven minutes, twenty-two seconds, a race record for thirty-three years, Paul, benefitting from a six-minute handicap, crossed the finish line first by just sixteen seconds. He was the first Marin County resident to win the Dipsea. After his death in 1990, a plaque was placed outside Town Hall in San Anselmo that reads, "Paul Chirone, 1937 Dipsea Champion. If You Can't Bring Happiness to Yourself, Bring It to Others."[2]

41

Olema History:
A Shipwreck, a Fiesta, and a Suicide

Pictured below is the Olema Hotel with the Post Office to the right at what is now the intersection of Sir Francis Drake Blvd. and Highway 1. A large portion of the Olema Valley was originally part of an 1836 Mexican land grant given to Mission San Rafael soldier, Rafael Garcia. Garcia named his ranch Tomales y Baulines, after giving an earlier grant, Rancho Las Baulines to his brother, Gregorio Briones. Garcia was the earliest settler in the Olema Valley and eventually grazed more than 3,000 cattle and 400 horses on his ranch. In the late 1840s, Joseph Revere, Garcia's neighbor in the nearby San Geronimo Valley, and grandson of American Revolution patriot Paul Revere, attended a fiesta at the Garcia Ranch which was later recounted in detail in Revere's 1876 book *Keel & Saddle*. His account provides us with a detailed and first-hand account of life on the ranchos before the gold rush transformed California.

The grand gathering had as its genesis a somewhat disastrous, but ultimately, fortuitous event for the Olema Valley residents. A sailing vessel from Bremen, mistaking Tomales Bay for the Port of San Francisco in the night, had run aground, depositing all of its "flotsam and jetsam" on the shores of the bay before breaking up and sinking.[1] The Garcia household, Revere, and other locals carted off casks of wine and liquor, hogsheads of exotic foods, and cases of silk and woolen fabrics, "the ship having been laden with an assorted cargo of European goods."[2] In his book, Revere recalled:

Don Rafael, and his hospitable family, quickly converted the occasion into one of festivity and an all-night celebration ensued, featuring the music of guitars and fiddles, the dancing of the waltz and "jarabe," the consumption of vast quantities of champagne and pâté de foie gras, while the elders played monte and euchre; the night ending with the revelers falling asleep on the grass around the adobe or enjoying each other's company in the quiet hours of pre-dawn.[3]

However, the high point of the Mexican Land Grant era was soon to end with California's statehood when land and boundary disputes, and sometimes downright swindles, ended up favoring the American settler over the Mexican families that resided

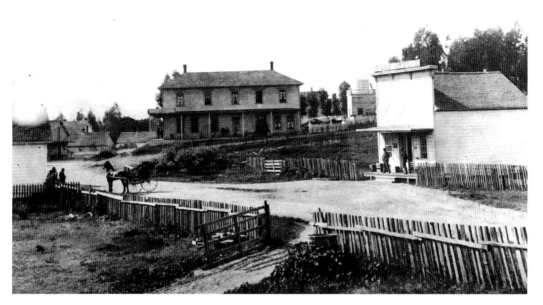

Olema Inn and Post Office, 1892.

on the land. The Garcias began selling off their holdings in the 1850s and 1860s to pay their debts and a new breed of Yankee landowners took control of the Tomales Y Baulines area. In 1857, Benjamin Winslow secured over 500 acres of the land grant and built a hotel and tavern there, establishing the town that he would name Olema (Coast Miwok for "coyote"). The town grew into the valley's commercial center, with stores, saloons, hotels, and a post office with Winslow serving as its first postmaster. Commercial goods such as dairy products, lumber, and paper from Samuel P. Taylor's Pioneer Paper Mill were transported through the valley on the way to ships anchored at Bolinas. For many years the town was the junction stop on the San Rafael to Olema stagecoach line that also served the towns of Bolinas, Willow Camp (Stinson Beach) and Tomales. Over time it acquired an unsavory reputation as a wild and often dangerous locale due to its hard-drinking and transient clientele.

The families of attorney James Shafter and his son, Payne, also purchased thousands of acres around Olema adding to their enormous and profitable Pt. Reyes properties. The Shafter's owned numerous dairies, raised cattle and horses, operated a stagecoach from Tocaloma to Bolinas, cut thousands of trees for firewood, and built a racetrack for their large stable of horses. For over thirty years, the Shafters were the wealthiest and most influential family in the area. In 1874, as the North Pacific Coast Railroad looked for a route west from central Marin, the ridge east of Olema was deemed too steep for a rail line. The tracks instead followed Lagunitas Creek and terminated at what is now Pt. Reyes Station, a town that soon outgrew Olema as the commercial hub of the valley.

Winslow's original Olema House was a store, bar and hotel combined, that he managed with his wife, Margaret. It burned down in 1876 and was rebuilt later that

year. Ownership passed to John Nelson, a local dairyman and stagecoach driver on the San Rafael to Olema route and was referred to as both Nelson's Hotel and The Olema Hotel. Early advertisements for the establishment advertised the hotel as providing visitors with accommodations for a day or a month along with transportation to and from the railway station in Pt. Reyes. In 1898, John Nelson was killed when he was thrown from his horse-drawn wagon on the San Rafael to Olema road. His sons, Edgar and Walter would run the hotel well into the 1940s. A 1916 *San Francisco Chronicle* notice boasted that the hotel featured, "Beautiful shaded grounds, tennis and croquet courts, a large new swimming pool, boating, fishing, etc."[4]

At the onset of World War II, the hotel was commandeered by the army for a barracks and Edgar, age seventy-five, distraught and disappointed walked into the hotel's garden and shot himself. After the war, it fell into disrepair under the management of Ruth Ruoff and was condemned in 1966. However, with the establishment of the Pt. Reyes National Seashore, Olema found new life and the hotel was renovated and reopened a few years later as The Olema Inn. Today, the recognizable, and stately old building is home to the restaurant, Sir & Star at Hotel Olema.

42
Pioneer Paper Mill:
Samuel Taylor's West Marin Empire

Samuel P. Taylor State Park, nestled along Lagunitas Creek in West Marin, is one of the glittering jewels of Marin County. Its namesake, Samuel Penfield Taylor, sailed to California in 1849 from New York to seek his fortune in the early days of the gold rush. Upon arrival, the crew and passengers rushed to the gold fields abandoning Samuel and the ship at the San Francisco wharves. Taylor, a savvy twenty-two-year-old, realized that there was money to be made cooking and selling meals in the busy streets of San Francisco and set up an "egg and bacon" stand on the wharf next to the ship.[1] Within a very short time, he earned the finances to enter the lumber business with a partner, Isaac Cook, at the corner of California and Drumm streets.

In 1853, Taylor traveled to Tuolumne County to prospect for gold and returned with $5,700 that he used to expand his lumber business. While searching for good timberland in West Marin, he found the perfect site along Arroyo de San Geronimo for his paper mill, a business his father operated back in New York. He purchased 100 acres for $505 from Mexican land grantee, Rafael Garcia. A year later, Taylor returned to Fall River, Massachusetts, to buy the machinery for his mill. While back east, he met schoolteacher Sarah Washington Irving and married her within a year. They returned to San Francisco together, and in 1856 built the first paper mill on the west coast providing San Francisco with newsprint for its three daily newspapers. They named it The Pioneer Paper Mill Company, the town that grew around it Taylorville, and the creek Papermill Creek. The original mill was powered by a water wheel that ran the machinery. In 1870 Samuel and Sarah opened the Taylor Hotel and Camp Taylor, a tent camping resort, for city dwellers looking to escape the fog and crowds of San Francisco.

For the first two decades of the mill's operation, Taylor transported his newsprint with ox-driven carts over the Bolinas Ridge to a schooner in Bolinas where it was shipped to San Francisco. However, when the North Pacific Coast Railroad was completed in 1875, a depot was built at Taylorville and his transportation challenges eased and campers and vacationers could travel to Camp Taylor more quickly and in comfort. Taylor purchased another 2,000 nearby acres, and in 1884 the mill was enlarged, converted to steam power and the hotel rebuilt and renamed the Hotel Azalea.

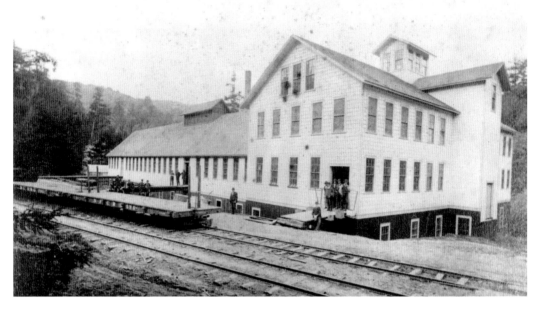

Samuel P. Taylor's Pioneer Paper Mill on Lagunitas Creek, 1884.

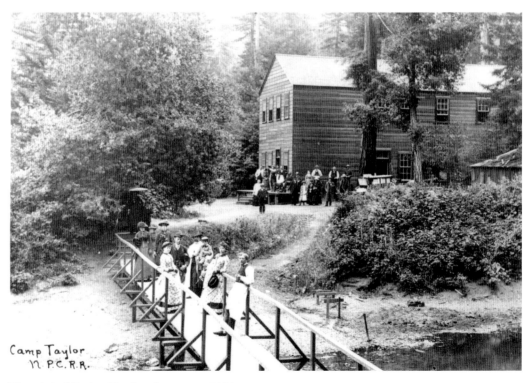

The original Taylor Hotel and guests, *c.* 1880

In its heyday, Taylorville had a black powder mill, a fur tannery, a tanbark mill, a grocery store, laundry, saloon, butcher shop, dance hall, riding stables, post office and train station. Samuel Taylor became a San Francisco supervisor and was a member of the 1856 Vigilante Committee that attempted to clean up the corruption and graft of city government. Sarah, meanwhile, became an active opponent of the smuggling of Chinese girls and women into the port of San Francisco to work as prostitutes in the mining towns and cities. According to an 1856 *Sacramento Daily Union* editorial this system was, "not surpassed in abominable infamy."[2] She often boarded incoming ships convincing captains to release the girls to her care and taking them to the Chinatown Presbyterian Mission which she helped establish. Over the next few decades, Samuel and Sarah raised seven sons, splitting time between their homes in San Francisco and Taylorville. In 1886, Samuel P. Taylor died and was buried on Mt. Barnabe near his paper mill, which he'd named after his favorite mule. After the economic Panic of 1893, the company was sold, and the mill and hotel passed into other hands. Both eventually burned down in a 1916 fire and Camp Taylor began a second life as a more rustic campground. The State of California took possession of the land in 1945 for non-payment of taxes and Samuel P. Taylor State Park with its beautiful redwood groves was established and preserved for future generations to enjoy.

43
The Tocaloma Hotel :
A Popular Destination for
Sportsmen, Bicyclists and Campers

Just before Sir Francis Drake Blvd. climbs over the steep hill to the town of Olema, Lagunitas Creek makes a sharp turn north to wind its way around the Olema Grade to Pt Reyes and Tomales Bay. It was at that location in the 1870s that the small hamlet of Tocaloma began to grow. Swiss immigrant Giuseppe Codoni purchased over 600 acres in the area from Giovanni Giacomini and expanded the dairy operations there. When the North Pacific Coast Railroad began operations in the mid-1870s, Tocaloma became a station stop along the line. It was conveniently situated at the junction of the San Rafael to Olema Stagecoach Road and the railroad line running between Sausalito and the timber lands and dairies of Marin and Sonoma.

In 1879, John Lycurgus built the first hotel on the site across Lagunitas Creek from Codoni's Ranch. The hotel catered to hunters, fisherman, hikers, and campers who wanted to escape the city and its often fog-shrouded neighborhoods. Lycurgus sold the hotel to another proprietor, Joseph Adams in 1882 who subsequently lost it in an 1885 fire. In 1889, French-born hotel keeper John Bertrand constructed a much grander hotel, pictured below, that had more than forty rooms, a dancehall, billiard room, banquet room, croquet grounds, tent-cabins, and outdoor swings and hiking paths that invited guests to enjoy the surrounding environs. By the 1890s, Bertrand's Hotel, as it came to be known, was a popular resort for travelers on the rail and stage lines and as a destination for vacationers, sportsmen, bicyclists, and campers. Trains ran two or three times a day and travelers could reach Tocaloma from San Francisco in a little more than two hours via the rail and ferry service from Sausalito. By the mid-1890s Bertrand also purchased the Azalea Hotel at nearby Camp Taylor, another popular resort. Advertisements for the resorts touted the fine cuisine, sunny climate and fantastic fishing and hunting opportunities in and around Tocaloma. A 1902 *San Francisco Call* article recounted how one angler, Leon Jessu, "had the star basket of the day" after catching 172 trout on the opening day of the fishing season between Camp Taylor and Tocaloma.[1] The hotel was also a favorite stop for the many bicycling clubs of the era including the Bay City Wheelman, Pacific Cycling Club, and the Camera Club Cyclists. Tocaloma began showing up on maps of

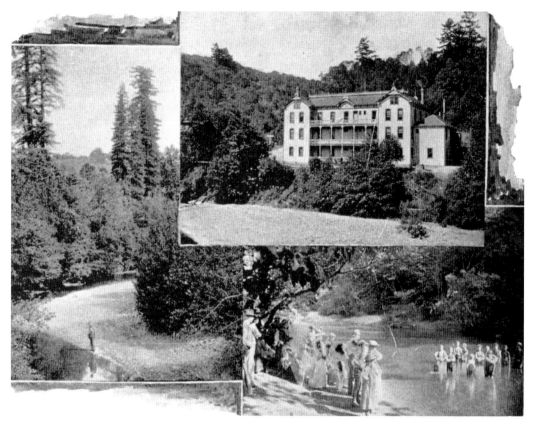

Composite photograph of Tocaloma Hotel with local attractions.

Marin and the small community established a post office in 1891 that remained open until 1919.

The hotel was bought by popular San Francisco restaurateur Caesar Ronchi in January 1914 who, reportedly, fled the city with his wife, Isolina, after informing on an "Italian bunko gang."[2] The couple continued providing fine dining and luxurious accommodations to their guests, but misfortune struck the hotel once again in the winter of 1916 when it was destroyed by a fire that started in a defective kitchen flue. Just a few months before, the long-standing Azalea Hotel also succumbed to flames at Camp Taylor. The following year Mr. Ronchi built a much smaller building and named it Caesar's Tavern. It was a popular roadhouse throughout the 1920s and 1930s, catering to motorists traveling the improved roadway and rebuilt bridges between Fairfax and Olema. By some accounts, Caesar's was also a spot where patrons could imbibe bootlegged liquor during Prohibition. In later years, with the hotel gone, the railway line abandoned and the fish population dwindling in Lagunitas Creek due to damming upstream, the roadhouse eventually closed and Tocaloma became a passing afterthought to motorists traveling the West Marin highways.

44

The Early Days of Inverness and the Inverness Store

Like so many stories of early California, settlers in the Pt. Reyes Peninsula and Inverness area were embroiled in an almost incomprehensible web of land disputes, foreclosures, swindles and lawsuits. The original Mexican land grant legatees, and many to whom they sold portions of their land, battled in court over boundary lines, land use, and property taxes. After the judicial dust cleared in 1858, attorneys arguing the disputes, Oscar and James Shafter, ended up owning a large portion of the Pt. Reyes peninsula. Along with Oscar's son-in-law, Charles Howard, they built the largest and most successful dairy business in the state. In 1889, James Shafter subdivided the land in the Inverness area (named after his ancestor's home in Scotland) and planned to build a large resort hotel along the west side of Tomales Bay. Prospective buyers were brought to the area via train and ferry to camp out before selecting lots to purchase. However, the scheme did not work as planned and after James Shafter's death in 1892, his son, Payne, and daughter, Julia, managed the property.

The first permanent home in the area was built by Alexander Bailey who also built the town's first post office and a wharf on the west side of the bay. By 1900 the town was growing slowly with a number of east bay residents, many who worked or taught at the University of California, building homes designed by architects Bernard Maybeck and Julia Morgan.

The Inverness Store, built in 1900, was owned and operated by local grocer Attilio Martinelli and his wife Jennie. Julia Shafter sold him the frontage property with the conditions that he would not, "sell liquor, keep goats or hogs, operate a brewery, cemetery, or any other business offensive to the senses."[1] The original store collapsed in the 1906 San Francisco earthquake, but was rebuilt within three months when a second story was added. In the ensuing decades, Inverness grew as displaced families from the earthquake and those seeking a simpler, quieter life began purchasing the lots being sold by the Shafters. Attilio, who became a Marin Supervisor and leading citizen in the county, would eventually own all of Inverness' main street, which featured a general store, a new post office, candy store, garage, warehouse and the town's only telephone, operated on a switchboard by his wife, Jennie. The Inverness store continued to supply

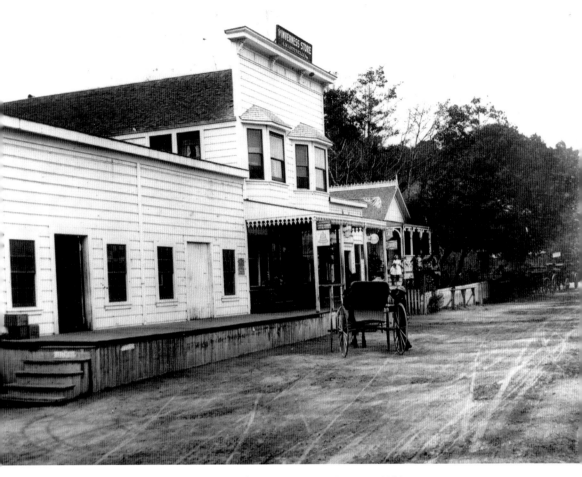

Attilio Martinelli's Inverness Store and Inverness Main Street, *c.* 1909.

and feed summer visitors who could rent a rustic cottage, stay at Mary Burris' Highland Lodge, sail on Tomales Bay from Brock Schrieber's boathouse and pier, or enjoy the sun and surf offered by any one of the many sandy beaches just outside of town. Today, visitors can visit the same downtown Inverness buildings that presently house the post office, the Saltwater Restaurant & Oyster Bar and the law offices of Martha Howard.

The "Country Club":
Exclusive Playground for
San Francisco's Pacific Union Club

Today, hikers wandering down the Bear Valley Trail towards the beaches of Pt. Reyes National Seashore pass a large, lovely meadow on their left known as Divide Meadow. Emerging from the mixed forest of pine, oak and bay, visitors are greeted by the often-sun-drenched meadow that can provide a sunny picnic or resting spot along the trail. In a previous life this meadow was home to the "The Country Club"; a private resort belonging to the wealthy, influential members of San Francisco's Pacific Union Club. The City's movers and shakers first leased the land from the Shafter and Howard families in 1890, and soon after, purchased a portion on which they built a luxurious club house. The Country Club offered fine dining, a billiard room and library, a social hall, thirty-five elegant rooms for overnight visitors, and fully stocked stables and kennels. Members and their guests could hunt and hike on 76,000 acres of pristine land, and fish in numerous lakes stocked with salmon, bass, and trout.

A *San Francisco Chronicle* article in 1893 described the Country Club as, "the premier sportsmen organization" of California and "the finest preserve in America."[1] Continuing, *The Call* reported that, "its immensity overpowers the visitor while the variety of game to be found causes him to pause in wonder."[2] The article waxed poetic in describing the Clubhouse's interior as, "equipped with every possible luxury and convenience calculated to either secure the comfort or enjoyment of the members."[3] Membership in The Country Club was initially set at 100, but increased to 125 within two years. However, the club's popularity lasted only a few decades and membership in the resort began to dwindle in the second decade of the twentieth century.

In 1919, the Shafter and Howard heirs sold the land to San Francisco beer distributor and bottler, John Rapp, to pay off family debts. By the early 1930s membership in The Country Club dwindled to just a handful and the hunting and fishing resort passed into memory. The building was still standing in the early 1950s when the land was part of the large Kelham ranch but was demolished soon after. Between 1962 and 1970, thanks to the efforts of congressman Clem Miller, his widow, Katie Miller Johnson, Peter Behr and many others in and out of government, the Pt. Reyes National Seashore was established, including the Bear Valley region. Now, "the finest preserve in America" can be enjoyed by all, free of charge, and the local animal and fish populations left in relative peace.

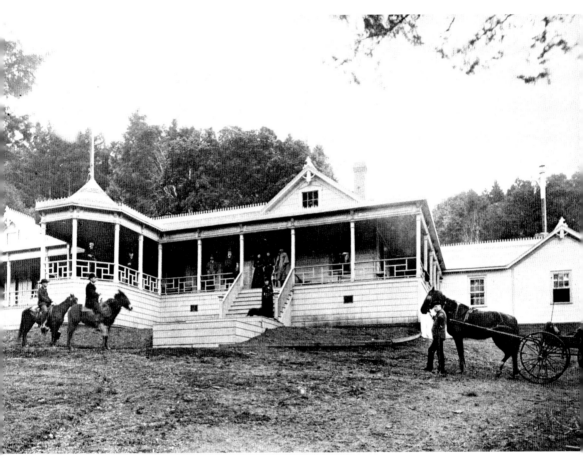

The "Country Club" lodge and resort in Bear Valley, *c.* 1893.

46

Tomales,
"The Live Town of Our Coast Line"

The town of Tomales, once the site of a Miwok village known as Utumia, was settled by Irish immigrant, John Keys in 1850. While traveling from San Francisco to Bodega Bay, Keys came upon a navigable creek that flowed into Tomales Bay and realized the economic potential for shipping goods to San Francisco. He had previously purchased portions of the old Bolsa de Tomales land grant near Bodega Point and was raising the first crop of potatoes in the region. To protect his claim on the creek, he built a house near the stream that still bears his name. With his partner, Alexander Noble, Keys bought a small schooner, *The Spray*, and transported their bumper crop of potatoes to San Francisco. Two years later, Keys entered a partnership with early California pioneer, Warren Dutton, and opened the first "trading post" in the Tomales area. Both Keys and Dutton ran successful shipping businesses carrying Tomales' expanding agricultural output of potatoes, grain, fish, lumber, butter and eggs to San Francisco via schooners docking at Keys Creek. In 1891 alone, Tomales raised over 15,000 tons of potatoes for export.

The Tomales Hotel opened in 1857 and was advertised as "Admirably Situated for Pleasure Parties from Petaluma and Santa Rosa."[1] Within a few years, Tomales was a thriving town with two churches, several stores and rollicking saloons along its main street. A 1887 *Marin County Journal* article noted that in the coming weeks, Tomales was to host a St. Brendan Society picnic that was to be "the grandest event of the spring in this county", a July 4 celebration at Keyes' grove and a fete for the Swiss National Day of Independence "that would send an echo of patriotic remembrance and devotion from the Sierras to the Alps." [2] The same article boasted that Tomales was "The live town of our coast line."[3]

Keys and Dutton eventually had a falling out that resulted in Keys having Dutton and his employees arrested for building a road that impeded the navigability of the creek estuary. Keys died a few years later and Dutton would go on to become the leading citizen of Tomales. He was the first postmaster of the town, President of the Tomales Bank, the Wells Fargo station agent, county assessor, and an official of the North Pacific Coast Railroad. Dutton also donated the land and oversaw the construction of the

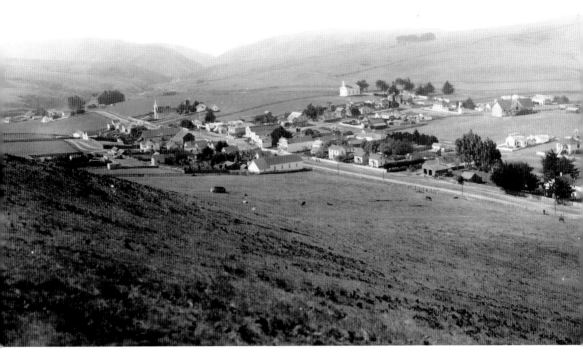

View of Tomales, looking southwest, with Presbyterian Church on the hillside above, 1898.

Presbyterian Church seen in the photograph on the hill. The completion of the North Pacific Coast Railroad in 1875 increased commerce and visitors to the area, and along with increasing siltation in the creek from grazing and farming, helped put an end to the sea-borne trade.

By 1900 Tomales was the second largest city in Marin and contending for the county seat. The great 1906 San Francisco Earthquake nearly decimated the town and newspapers described Tomales as, "a pile of ruins" with nearly every large building in the town completely flattened or destroyed.[4] The citizens of the town would rebuild, but the hopes of hosting the county seat of government never came to pass and the region would maintain its rural and agricultural economy. Today, a drive up the coast to Tomales can still transport the traveler back to an earlier time with its gently rolling hills, beautiful coastline, and small-town flavor.

47

A Christmas Day Storm and the Toppling of a Steeple

Over the decades, there have been many severe winter storms that have wrought extensive destruction across Marin County. The Christmas Day storm of 1921 is one of those that laid waste to virtually every corner of Marin County. Newspaper accounts in the days following the deluge described flooding throughout the county, boats and bayside structures damaged or destroyed in Sausalito, Belvedere, and Bolinas, with trees blown down and roofs blown off in every town. Utility services were interrupted for days, cars were thrown off the road, train service was stopped, snow fell on Mt. Tam and more than 4 inches of frigid rain poured down from the skies.

In the first photograph below, taken a few days after the storm, St. Mary's Church in Nicasio is without its steeple, torn from the building as it was blown off its foundation at the height of the tempest. Over the next year, the townspeople collected funds to repair the church at local dances, dinners and gatherings, usually hosted at the Nicasio Hotel, seen just to the right of the church. The hotel and church shared a long history together, even in 1921, as they were both built in 1867. The hotel was at the center of town life welcoming guests from all over the state and was instrumental in organizing annual fundraisers that benefited the church. The Hotel burned down in 1940 and the current restaurant and music venue, Rancho Nicasio, now sits on the former site.

Across the square from the church can be seen William Miller's two-story "General Merchandise" store also built in 1867. Miller leased the building to several managers in its early years while the Nicasio Grange, No. 155, Patrons of Husbandry, used the upper floor for their meetings. In 1885 the Nicasio Druids Grove, No. 42, purchased the entire building from Miller. They also used the top floor for meetings and, like Miller, leased out the store to a series of operators until local rancher, Frank Rodgers began managing the mercantile in the 1890s. He and his son Frank Jr. ran the family store for nearly thirty years until they sold it in 1927. The store is remembered as the commercial hub of the growing town as it not only sold a large assortment of dry and canned goods, but also contained a Wells Fargo office, Post Office, and saloon with large kegs of beer on tap. There was even a bocce ball court on one side of the store that was kept clean and ready for players by all the Rodgers children.

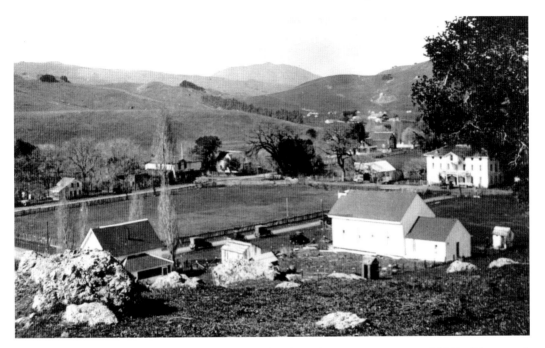

Nicasio's St. Mary's church without its steeple after Christmas Day storm of 1921. (*Photograph by Madison Devlin*)

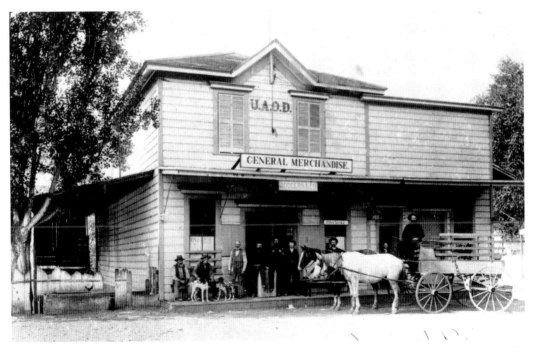

Frank Rodgers' general merchandise store with Druids Hall on upper story. (Photograph by Madison Devlin)

Nicasio's town square with its little league ballfield seems to the occasional passerby a little oversized for such a small town. When the hotel, church and store were built, residents harbored great hopes for the town and lobbied for years to have the county seat of government moved there from San Rafael. The plan was to have numerous government buildings and a thriving town center surrounding the perimeter of the large square. At the time, Nicasio was very near the geographic center of the county and most of the county's population resided in West Marin. However, in 1872 the State Legislature approved San Rafael as the permanent county seat. No longer in need of an impressive town square, Nicasians did the next best thing and built their own 'field of dreams' next to the iconic St. Mary's Church which has changed little since its 1922 restoration.

Woodacre and
the "Lovely" San Geronimo Valley

"The Cañada of San Geronimo is one of the loveliest valleys in California, shut in by lofty hills, the sides of which are covered with redwood forests and pines of several kinds, and interspersed with many flowering trees and shrubs peculiar to the country."[1] So wrote Joseph Warren Revere, grandson of Paul Revere, in his book *Keel & Saddle* when he first set eyes on the San Geronimo Valley.

Though no permanent Miwok settlements were in the valley, the Lagunitas Creek watershed was traditional Miwok hunting and fishing grounds for thousands of years. During the Spanish mission and Mexican Land Grant eras the valley passed from the stewardship of the Miwok and was used periodically to graze cattle. In 1844, Rafael Cacho, an officer in the Mexican Army was awarded the land grant, La Cañada de San Geronimo, for his service in the military. Two years later, Cacho sold "two square leagues" to Joseph Revere, a lieutenant in the U.S. Navy, who participated in the Bear Flag Revolt and was the individual who raised the American Flag over the Presidio in Sonoma.[2] On his way back to Monterey, Revere fell in love with the San Geronimo Valley while hunting elk on horseback. He built a small adobe near the intersection of today's Sir Francis Drake Blvd. and Nicasio Rd. Revere planted food crops and grazed cattle that he would sell for astonishing profits along with tools and household goods on frequent trips to the mining towns after gold was discovered in 1848.

A few years later, he sold his land to move on to other adventures and much of the valley was eventually purchased by Adolph Mailliard in 1867. Maillard and his wife, Ann Ward, the daughter of a wealthy Boston family, built a large house in present-day Woodacre and moved from San Rafael to the valley in 1873. In later years, their home served as the Woodacre Improvement Club until it was consumed by fire in 1958. The Mailliard family raised cattle and operated a large dairy in the hills above their home. When the railroad came to the valley, Mailliard, who was an investor, donated land for the right-of-way and two stations were built: one near the family home and dairy and another near the intersection of today's Railroad Ave and Park St. To pay off some debts, Mailliard sold some of the family's holdings to James and Thomas Roy and John and William Dickson who had leased the land since 1870. The Dickson Ranch is still in

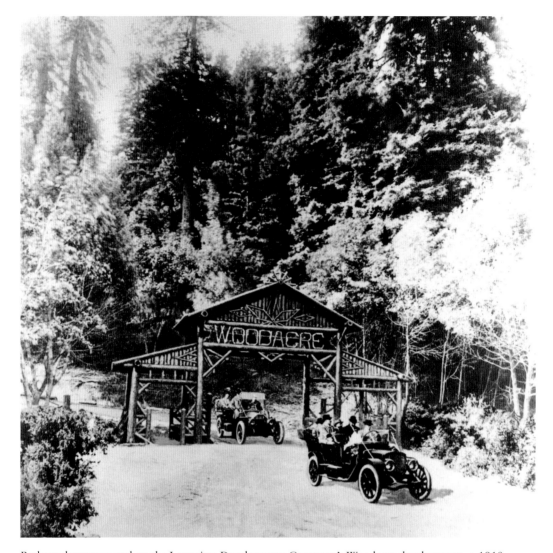

Redwood entrance arch to the Lagunitas Development Company's Woodacre development, *c.* 1910.

existence today and offers livery service to horse owners along with riding lessons and camps for riders of all ages. A section of the Roy land further west is now known as "Roy's Redwoods," a Marin County State Park available to hikers just off Nicasio Rd.

The Mailliard family began to subdivide their ranch in 1904 and eventually sold the greater portion to the Lagunitas Development Co. which helped create the communities of Lagunitas, San Geronimo, Woodacre, and Forest Knolls. The wooden arch in the photograph was built to attract potential homebuyers and greet visitors to the development. The arch was just west of today's "downtown" Woodacre where residents today can shop at The Woodacre Country Market & Deli, pick up mail at the post-office or wait for a bus if they choose to leave, "one of the loveliest valleys in California."

Marconi Conference Center: Once a Link in a Worldwide Telecommunications System

On a lovely, forested hillside overlooking Tomales Bay, just south of the town of Marshall, sits the 107-year-old Marconi Conference Center. It was gifted to the State of California in 1989 after a purchase made possible by the San Francisco Foundation and Buck Trust Fund financing. Originally built in 1913 to receive wireless telegraph signals from across the Atlantic Ocean, the Center's website boasts that, "Marconi continues in the tradition of communication by providing meeting and retreat services for the Bay Area."[1]

Guglielmo Marconi was an Italian Nobel Prize winning inventor and engineer whose pioneering work in radio wave transmission ushered in the era of long-distance communications and the "radio age." After groundbreaking work in Italy and England, Marconi began working on building transmission stations on both U.S. coastlines that would link North America with Asia and Europe. According to a *San Francisco Call* article: "The Marconi Wireless Telegraph Company purchased 1,114 acres of the Maggetti Ranch on the shore of Tomales Bay for $75,600."[2] The receiving station was built over the next year and the transmitting station placed further south in Bolinas. The geographically separate "duplex stations" were necessary as the noise from transmitting the signal obscured clear reception at the receiving end. These stations made it possible for messages to be received from New Brunswick, New Jersey, thus connecting Europe and the East Coast of the United States to the Pacific Coast and Hawaii. The new technology also enabled ship to shore communication and the Marconi wireless system has been credited with saving thousands of lives from shipwrecks, including the 712 survivors of the *Titanic* disaster. The receiving station required a one-mile-long antennae that was supported by seven 270-foot towers. In the photograph below, the two-story Craftsman style staff and visitors' hotel featured thirty-five rooms, a library, game room, lounge, and dining hall. To the right is the powerhouse that contained the boiler, transformers, storage batteries, and a workshop. Three of the towers supporting the antennae can be seen in the background.

Through World War I, the Marconi Wireless Telegraph Company of America was the dominant radio communications company in the United States. However, after the war,

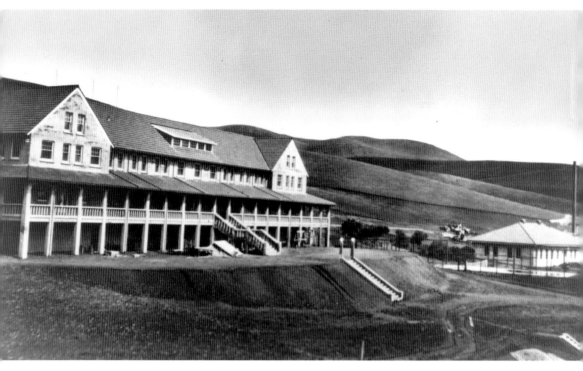

The Marconi Wireless transmitting station near Marshall on Tomales Bay, 1914.

pressure from the U.S. government forced the mostly foreign-owned Marconi company to sell its assets to RCA, a subsidiary of General Electric. GE operated the station until 1947. In the early 1960s, the infamous drug and alcohol rehabilitation organization, Synanon (some would say "cult") purchased the property and moved their headquarters to the Tomales site. After many brushes with the law, accusations of violence, and even a murder conviction, all exposed by the Pulitzer Prize-winning work of the *Pt. Reyes Light* newspaper, the site was put up for sale and passed into the hands of the State of California.

50

The Railroad Brings Life to Pt. Reyes Station

Though the photograph below was taken nearly 100 years ago, many of the buildings pictured still stand on Shoreline Highway (CA Highway 1) in Pt. Reyes Station. The large two-story wooden building in the right foreground is still called the Pt. Reyes Emporium and was one of two general mercantile stores in town. Today the building is home to Cabaline Country Clothing & Saddlery, Pt. Reyes Books and the Bovine Bakery, though the lower floor has been extended. Just east of the Emporium, on the same side of the street, sits a one-story structure with a scalloped front-façade that will soon be home to the long-established Station House Café. The small, white wooden building next door accommodates Black Mountain Weavers and the Marty Knapp Photo Gallery. Much further down the street the iconic, brick Grandi Building, named after its proprietor, Salvatore Grandi was built in 1915 on the site of the town's first hotel and saloon. The large wooden building with the bay window just before it was the original Grandi Mercantile Store and today it accommodates the Old Western Saloon. The lone building across the street was initially the Olema/Pt. Reyes train station and now serves as Pt. Reyes Station's post office.

The town of Pt. Reyes Station, originally called Olema Station, was little more than a cow pasture until the North Pacific Coast Railroad laid tracks to the area in 1875. With the coming of the railroad, it quickly outgrew other West Marin towns. Olema, two miles to the south, had been the largest settlement at the time, but engineers for the railroad bypassed the Olema grade as it was too steep for rail transport and laid their tracks along Lagunitas Creek to what is now Pt. Reyes Station. The train station and town sat on land owned by Galen and Mary Black Burdell, the daughter of Nicasio land grantee James Black. Within a year, the Burdells built the first hotel and saloon, and the town grew rapidly, soon bypassing Olema as the commercial and recreational hub of the area. With a rail line that connected to Sausalito and the San Francisco Bay ferry system and its easy access to shipping on Tomales Bay, the new town was ideally situated for commercial and passenger transportation. A post office was opened in 1882 and the town changed its name to Pt. Reyes, eventually settling on Pt. Reyes Station in 1891.

On the morning of April 18, 1906, Northern California experienced the most devastating earthquake in its recorded history. The San Andreas Fault, not yet named

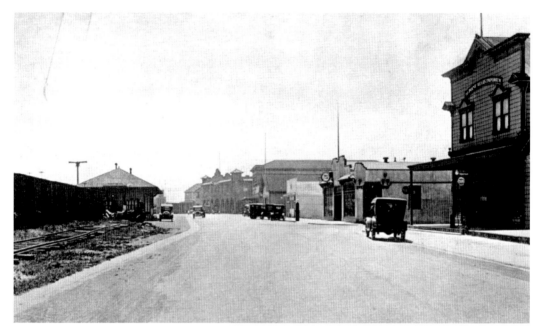

Downtown Pt. Reyes looking east, *c.* 1925.

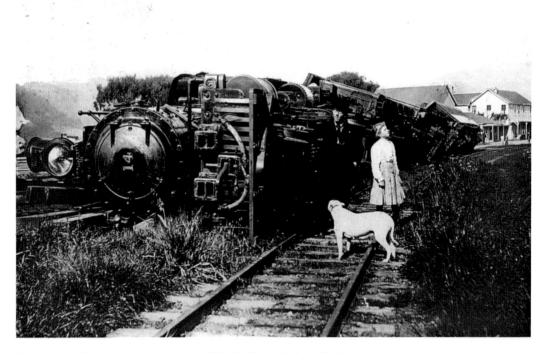

Pt. Reyes residents survey the wreck of North Shore Railroad's No. 14 engine after the 1906 San Francisco earthquake.

or even understood, ruptured and slipped along nearly 300 miles of its length. Because of it position directly over the San Andreas Fault, Pt. Reyes was especially hard hit, and visitors can still see some vestiges of the shifted earth by taking a walk along Bear Valley's Earthquake Trail. Many barns, granaries, homes, and buildings in West Marin were destroyed or damaged. A few farms had structures or fences that moved in opposite directions depending on what side of the fault line they were on. The curious onlookers above survey the overturned #14 steam locomotive of the North Shore Railroad. The earthquake packed enough punch to topple this nearly 10-ton engine and its cars without much trouble.

It has been estimated that the 1906 San Francisco Earthquake would have registered 7.9 to 8.0 on the modern-day Richter Scale and that the Pacific Tectonic Plate moved over 20 feet northwest in relation to the North American Plate. Geologists have since determined that the underlying geologic formation of the Pt. Reyes Peninsula matches up with the Tehachapi Mountains northeast of Los Angeles and the entire peninsula has gradually moved 400 miles northward over the last few million years.[1]

51

Pt. Reyes Lighthouse:
A Beacon of Safety for
Ocean-Going Vessels

Point Reyes peninsula, the windiest location on the Pacific Coast and the second foggiest place on the North American continent, has been the scene of hundreds of shipwrecks over the last 425 years. The first recorded sinking was the Spanish galleon *San Agustin* in 1595 and the most recent, the 27-foot sailboat *The Rosebud* in 2018. The dense fog, strong currents, and rocky coastline, so near the major port of San Francisco, have spelled the doom of many ships and taken the lives of thousands of seagoing passengers.

As shipping in the region increased dramatically after California statehood, a warning system for vessels navigating the dangerous waters off the peninsula was instituted. In 1870, the Point Reyes Lighthouse was built to warn ships of impending danger and provide a beacon light to help navigate the treacherous Northern California coast. The lighthouse's lens and mechanism were constructed in France in 1867 and shipped around Cape Horn to Drake's Bay. Situated 300 feet below the top of the cliff, the beacon had a "first order" (largest) Fresnel lens. It refracted and magnified the lamp light through crystal prisms which could be seen 24 miles away, more than doubling the range of earlier reflective lenses.[1] The rotation of the 36-inch-wide, 8.5-foot-diameter lens required a complex weight and gear system, not unlike many grandfather clocks, with a suspended weight supplying the force to turn the 6,000-lb. mechanism. Up until 1939, when the facility was electrified, keepers used fuel-oil as a light source and kept the oil-burning wicks trimmed for optimal brightness.

Though many ships have foundered or sunk along the Marin coastline since the Pt. Reyes lighthouse was built, it has undoubtedly saved countless other vessels from suffering the same fate. Within twenty years, a steam-powered siren, and later an electric powered foghorn, were installed lower on the cliff to warn vessels when the fog was too dense for the light to be seen. In the early days, a keeper and two or three assistants were responsible for lighting the lamp at sunset and maintaining the lens, lamp and rotating mechanism. In the late nineteenth century, the lonely, arduous and often dangerous work performed by the lighthouse keepers paid them from $500 to $800 a year plus room and board.

Pt. Reyes Lighthouse and steps leading to the cliff above.

In 1975, the U.S. Coast Guard installed an automated light, ending 105 years of lighthouse keeper history and transferred ownership to the National Park Service. Sightseers can visit the site by following Sir Francis Drake Blvd. to its westernmost end and climbing down the 360 steps to the historic, sixteen-sided, glass-enclosed "lantern-room" atop the tower.[2]

Fires on the Bay:
100 Years of Recreation,
Moonshine and Music

The Marshall Hotel, overlooking Tomales Bay, welcomed visitors for over 100 years before fire destroyed the inn in 1971. Originally named the Bay View Hotel, it was built in 1870 by the Marshall brothers, Hugh, James, Samuel, Alexander, and David. According to an 1896 *Marin Journal* article, the Marshalls starting from Kentucky "Removed to California, bringing with them a large drove of cattle, most of them milk cows. They settled at Tomales, took up a tract of land of over 1100 acres, and began a dairy and stock business, which grew in importance until it made the brothers very wealthy."[1]

The hotel provided vacationers with ample opportunities "for sailing, fishing, shooting and clamming" and was a stop on the soon to be completed North Pacific Coast Railroad (NPC).[2] The railway company decided to place a station at Marshall on their Sausalito to Cazadero line, no doubt encouraged by a $10,000 gift made by James Marshall. The NPC drummed up business by advertising local attractions to prospective tourists and sportsmen extolling the plentiful game and fish found in the Marshall/Tomales Bay area. The hotel had hot and cold salt-water baths, and rooms were furnished in "elegant Victorian décor, including brass beds kept highly polished."[3] The brothers also built a tavern and hardware store in 1873 that still stands today though it has been vacant since 1990.

The hotel suffered severe damage in an 1897 fire but was rebuilt in 1899 and renamed the Marshall Hotel. James Marshall's widow, Rachel, leased the land to proprietors Mr. and Mrs. John Shields who ran the inn and neighboring livery stable, tavern, and hardware store well into the 1930s. The hotel had nineteen rooms and was elegantly appointed in Victorian-style comforts. To celebrate the reopening of the new hotel, Mr. and Mrs. Shields hosted a Grand Ball & Supper on Saturday, December 23 that was attended by hundreds of residents from Olema to Tomales.

The hotel seems to have changed its name for a short period of time around the turn of the twentieth century as newspaper advertisements refer to the North Shore Hotel run by John Shields and Mrs. John Shields. In 1906, the devastating San Francisco earthquake caused the hotel to slip off its piers and into the bay, causing $15,000 of

damage. However, the Shields' rebuilt the inn and were back in business within a year. During Prohibition, the Marshall Hotel was known to be a dropping off point for illegal liquor coming down the Pacific Coast on its way to San Francisco.

The hotel passed through many hands in its later years and was occasionally remodeled and updated but kept its Victorian Charm until the end. During the late 1940s and early 1950s, science students from Modesto Junior College made an annual expedition to Marshall using the hotel as their headquarters to study the Tomales Bay flora and fauna. In the 1960s and early 1970s the inn hosted numerous musical guests and acts including a month-long folk festival taught by guitar teacher Rolf Cahn, Sunday performances of the Bay City Dixieland Jazz Band, weekly chamber music concerts by a trio named "Erotic Bach," and performances by folk legend and long-time Marin resident Mimi Farina with her musical partner Tom Jans. The photograph above was taken in 1971, the year the hotel met its final, fiery end.

The Marshall Hotel on Tomales Bay, 1971.

53

A Highway by Any Name Connects Us All

In 2021, local Marin County jurisdictions were asked to vote on renaming Sir Francis Drake Blvd., the principal highway that connects most towns and cities in the east–west corridor. The sea-faring Drake's early participation in the African slave trade and his place in history as representative of the European colonial powers convinced many residents to support a name change for the nearly forty-four-mile highway. Others felt that Drake's total contribution to history and the age of exploration along with the economic and personal impact of changing street signs, addresses and business names were opposed to the change. Residents throughout the county had the opportunity to voice their opinions through multiple online dialogues and at many county and town hall meetings. In the end, the County of Marin, and the towns of Ross, San Anselmo and Larkspur voted to keep the original name. The town of Fairfax voted to honor Marin's indigenous people and will rename the road the Coast Miwok Trail.

Whatever name modern-day residents prefer, the construction and completion of the highway in November 1929 was enthusiastically commemorated by all Marin County residents. Formerly known as the Manor to Point Reyes Road, the suggestion to name the road after the sixteenth-century English explorer was the idea of Point Reyes Station business owner Bill Scilacci. He believed the new name would boost commerce in the area while embracing the accepted historical record that Drake, in his ship *The Golden Hind*, had landed on the Pt. Reyes peninsula in 1579 and traded with the indigenous Coast Miwok.

On the day of the dedication ceremony, a procession of automobiles carrying over 200 residents and local dignitaries left the San Rafael Courthouse and drove the new highway to the town of Olema where they were met by scores of West Marin residents. The ceremony was held outside the Olema Hotel at the junction of the new highway and what was then Route 1 connecting Bolinas to the towns of Pt Reyes and Tomales. The San Rafael High School Band provided musical accompaniment and Miss Mary Menzies of San Rafael (front right, below) broke a bottle of champagne on the cement pavement and declared, "I christen thee Sir Francis Drake Highway."[1]

Contractor J. V. Galbraith completed the highway in ninety days, one month ahead of schedule and under budget. Marin County engineer Robert Messner supervised the

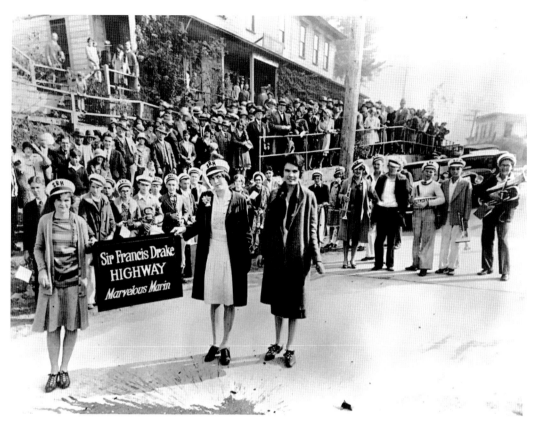

Mary Menzies of San Rafael christens the completion of Sir Francis Drake Boulevard at the dedication ceremony in front of the Olema Hotel, November 16, 1929.

project and, while doing so, pioneered the use of redwood joints between the roadway's concrete slabs to aid in expansion caused by temperature changes over the course of a year. The booster group "Marvelous Marin" oversaw the dedication ceremony and was primarily responsible for getting the $1,250,000 countywide bond measure passed in 1925 to pay for the construction of the highway. After the ceremony, over 250 guests drove to Pt. Reyes Station and were treated to a catered lunch, numerous speeches, award presentations, and music at the town's Forester's Hall. After the festivities, many of the celebrants drove over to Inverness to continue the celebration, then down to Bolinas and ended their daylong motoring journey at Stinson Beach before heading home on the new, cross-county highway.

54

"Surf's Up" at Stinson Beach

Hopefully, the beauty and serenity of the moment captured below, a glorious sunset at Stinson Beach, can refresh and comfort all of us who are "sheltering-at-home" and "social-distancing" in these difficult times. Longtime Marin IJ photographer Frankie Frost, barely a month on the job, caught these two local teenagers leaving the waves at the end of a long day of surfing on December 26, 1985. Allan Reeves of Bolinas and Peter Phibbs of Mill Valley were "stoked" to be out on the ocean that day and, in recent conversations with them via email and over the phone, they both fondly remembered the moment and the subsequent publishing of the photograph.[1] Allan and Peter were graduates of Tamalpais High School and along with other friends spent much of their free time riding their skateboards around town, down Mt. Tamalpis to the coast, and surfing the beaches of Stinson, Bolinas and Ocean Beach in San Francisco "which had the better surf" according to Reeves.[2] Peter also rode his BMX bike on courses at Blackie's Pasture in races sponsored by The Cove Bike Shop, and even got a "date" after the original publication of the photograph as a local girl contacted him to teach her how to surf.[3]

Stinson is known as a very accessible beach for surfers, if not the most challenging in the area. Winter storms occasionally form ideal sandbars that can turn what are called "close-out" waves, those that turn and break all at once, into "peaky," rideable waves that offer surfers longer, smoother rides. Although less challenging than other locations, surfers at Stinson must be aware of sharks roaming the surf. Stinson Beach lies within what is termed the Red Triangle, an area off the coast of California whose three geographic endpoints are Bodega Bay, the Farallon Islands and Big Sur. Sharks, many of them great whites, swim these waters in search of sea-lions, harbor seals, elephant seals, and otters. There was a fatal shark attack near Santa Cruz in May 2020 and an October 2021 attack off the Sonoma Coast where the surfer escaped with a severe injury to his leg after he "punched the Great White in the face."[4]

Allan and Peter still live and work in Northern California. Allan lives in Marin and is a certified, personal fitness trainer, an avid mountain biker and road cyclist. He is also the host, organizer, and guide for a company named France from Inside that organizes cycling and wine tours in the south of France. Peter is an artist specializing

Surfers Allan Reeves and Peter Phibbs at Stinson Beach, December 26, 1985. (*Photograph by Frankie Frost of the Marin Independent Journal*)

in wood carving and ceramics, having received a master's degree in ceramics from the University of Colorado at Boulder. Phibbs was also the head of the ceramics department at Colorado Mountain College for eight years. He lost nearly everything in Sonoma County's 2017 Tubbs fire and now lives and works on his art north of Jenner along the Gualala River. I want to thank both Allan and Peter for their kindness in sharing their memories.

55
Marin's Pacheco Family Legacy

It would be hard to find a pioneer, Californio family whose imprint on Marin County is more widespread and longer-lived than that of Ignacio Pacheco's. The two-story Pacheco house still stands today in the unincorporated community of Ignacio, just south of the city of Novato, and was built by his son, Gumesindo, in 1876 on the original ranch property. Ignacio (Ygnacio in *Español*) was born in 1808 at Pueblo de San Jose and was the son of the *alcalde*, or mayor. He joined the San Francisco Presidio garrison as a teenager and was eventually promoted to sergeant. Upon his retirement, Ignacio was given a land grant by California Governor Juan Bautista Alvarado y Vallejo just north of Sonoma called Rancho Agua Caliente. However, he found the land there unsuitable for his agricultural and ranching needs and in 1840 was deeded the Rancho San Jose grant of 6,600 acres north of San Rafael that ran from the San Pablo Bay west to Nicasio.

The Pacheco family raised cattle and horses for stock and racing. Ignacio is credited with planting the first vineyards in Marin County along with numerous fruit orchards. He had nine children by three different wives, Maria Josefa Higuera, Maria Guadalupe Duarte, and Maria Loreto Duarte, the younger sister of his second wife. The Pacheco family revered education and built a schoolroom in the original adobe house for the education of their children and those of their neighbors. In later years, the family donated nearby land for a schoolhouse that would eventually become the first school of the San Jose School District of Novato. Ignacio was an influential and respected rancher and was noted for being a crack shot and fine swordsman. His great-great grandson, Herb Rowland, tells a story of Ignacio challenging U.S. Army Major John C. Fremont to a duel in 1846 just before the Bear Flag Rebellion that wrestled control of California from Mexico. Fremont was riding north with twenty-five men and Kit Carson as his guide and interpreter, when he demanded that Ygnacio deliver up his finest horses. Ignacio had sent his best horses north in anticipation of losing them to Fremont's armed group and pointed at some broken-down, sway-back nags, saying, "There they are."[1] Fremont became furious and called him "a liar".[2] Ignacio challenged him to a duel, but Fremont backed down when Kit Carson revealed that Ignacio was known as one of the best shots and swordsman in California.

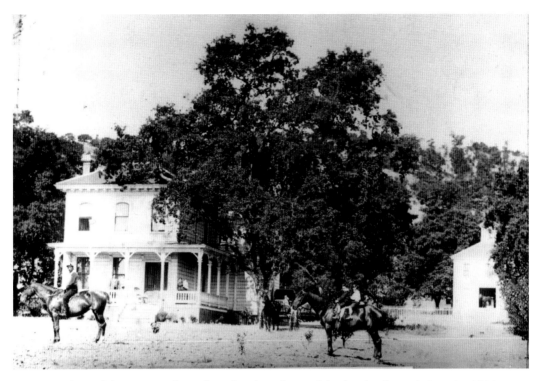

Members of the Gumesindo Pacheco family in front of the family's home in Ignacio, 1881.

On November 29, 1864, Ignacio Pacheco died, leaving his wife and children his entire estate. He is buried at Mt. Olivet Cemetery in San Rafael along with his third wife, Maria Loreto. She lived until 1891 and married twice more, including West Marin pioneer and landowner James Black. Over the years, family members sold off most of the land except for the Ignacio home site. However, the Pacheco family is still remembered across the county in the winery, shopping center, creek, neighborhoods, and numerous street names that still bear their first and last names.

Today, the Pacheco Valley winery sits on 70 acres of the original San Jose land grant just west of Highway 101. It is managed by Herb Rowland who is a seventh generation Californian. He and his wife Debbie run the family business from the same house, pictured above, that his great-grandfather built in 1876.

The Hiribarrens:
Early Entrepreneurs of Novato

Pictured below are Novato pioneer Captain Leon Hiribarren holding his granddaughter Madeleine, with his wife Marie to his right. The man in the shadows to his left may be his son, Augere. Leon was born in the Basque region of France and Marie was from Newfoundland, Canada. In the early 1890s, Mr. Hiribarren was living and working in San Francisco where he operated sailing vessels that transported farm products from Marin County to the city. Hiribarren first took a liking to the Novato area on one of his trips north to pick up apples and pears from the orchards of Joseph Sweetser and Francis DeLong. At the time, the Sweetser/Delong land was believed to support the largest apple orchard in the U.S. Within a few years, Hiribarren's lucrative water-borne trade began to suffer, as he recalled, "When the trains came."[1] He decided to move his family from San Francisco and settle in the Novato area and bought a home in "Old Town" near today's Redwood Blvd.

Hiribarren opened a general store named The Half Way House but sold it after a couple of years and moved the business west to Novato's "New Town," a bustling commercial area that was springing up along Grant Avenue. Named the Novato House but often referred to as "The Corner," it was a combination hotel and saloon that was located at the intersection of the current Scott St. and Grant Ave. In 1899, Captain Hiribarren erected a building next door and opened a livery stable that served both his hotel patrons and Novato residents. In the early days, traveling salesmen or "drummers" would ride the train to Novato and stay at the Novato House.[2] From there, they could rent a horse and wagon to sell their wares to local farmers who could not easily get to San Francisco. The Hiribarrens were leading citizens of the town, bought and sold numerous properties in the area and joined the local chapter of the Druids Hall.

Marie Hiribarren is remembered for serving guests of the hotel and tavern elaborate meals for fifty cents that always included a bottle of wine. She also volunteered as the town nurse, accompanying local physician Dr. Kusar on his house calls to help deliver babies or care for the sick. In 1900, Captain Hiribarren handed the business over to his son, Augere, and his wife, Anna, who operated it for several years until selling in 1906. At that point, the family began producing fine cheeses such as Neufchatel, Camembert,

Leon and Marie Hiribarren with their granddaughter Madeleine, in front of their general store, the Novato House, *c.* 1903.

and Brie made from the milk of locally raised cattle. Marie died in April 1911 and Leon in October 1920. Their son, Augere, continued making cheese until Prohibition outlawed the sale of wine and liquor which severely impacted the sale of fine cheeses to restaurants and taverns. Their granddaughter, Madeleine York, lived in the family home on Railroad Ave. in Novato until her death in 1975 in a house that still stands today.

57

Historic Black Point Inn

The Black Point Inn of Novato, located just west of where the Petaluma River enters the San Francisco Bay, was the hub of the Black Point community for close to ninety years. Most sources agree that the first building there was constructed around 1890. Local historians tell the tale of a Norwegian sea captain who, giving up his ocean-going life, beached his boat on the point and built the inn himself. Originally, it was a store, tavern and stagecoach stop for guests traveling the route of today's Highway 37. Through the decades, the inn served the local community as a post office, hotel, saloon and restaurant, church, railway stop, and community meeting house. By all accounts, Black Point got its name from the very dark woodland that covered the hills of the point as seen from ships on the bay.

Its location near the mouth of the Petaluma River attracted both hunters and fisherman and, over the years, many vacationers built summer cottages in the area. There are records of the property being purchased in 1920 by William Miller and his wife, May. The census of that year lists them as postmaster and assistant postmaster for Black Point. Three years later, William died, and May married Louis Nave. The two managed the Inn, store, and post office until selling it in 1944, at which time they divorced. There were ten hotel rooms upstairs, and a rosewood bar, restaurant, banquet room, post office, and grocery store on the first floor. During Prohibition, the inn had an unsavory reputation as a speakeasy due to its secluded location near the bay where illegal shipments of liquor could be brought in undetected. That reputation spilled into the later decades when a brawl erupted at the inn in 1959 between two women over a hurled insult that soon developed into a raging street fight. Three women were eventually arrested three miles away as, "Battle Lines shifted back and forth from Black Point Inn to the Plush Horse Bar and the center of Grant Avenue in Novato."[1]

The Black Point Inn changed hands several times over the ensuing decades and became a more family-oriented establishment while still maintaining its status as a favorite watering hole and eatery. An outdoor dining patio and swimming pool were installed to cater to the growing number of families that were moving into the fast-growing neighborhoods of Novato. Advertisements for art shows, rodeos and chess

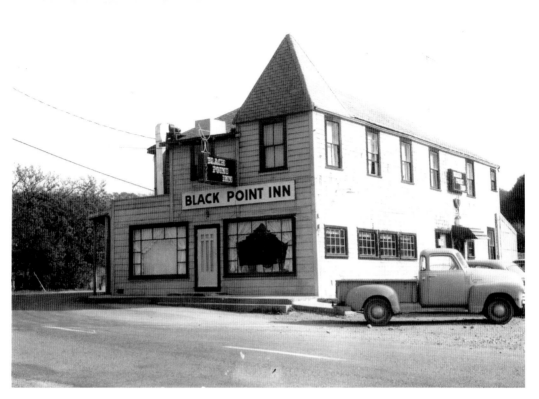

The Black Point Inn, restaurant, and tavern east of downtown Novato, *c.* 1955.

club competitions sponsored by the Inn appeared in local newspapers while evening entertainments included "Live music by the Dick Saltzman Trio: Direct from the Hyatt Regency, San Fran", and the popular jazz and pop group, The Duxbury Trio.[2] The food was first class and included American, continental, and Chinese cuisine courtesy of Al & Joe Louie, chefs at the popular 751 Club in San Rafael. Harry Craft's column in the *Daily Independent Journal*, Dining Out & Inns, always gave the Black Point Inn top marks for its food, ambiance, and service. Unfortunately, like so many historic establishments, the much-loved roadhouse was gutted by fire on April 29, 1976, and never rebuilt. The property is now home to the Kelleher Lumber Co. of Black Point.

58

World War I Flying Ace Lloyd Andrews Hamilton and Hamilton Field

Hamilton Airfield in Novato, now known as the Hamilton Field neighborhood, owes its name to one of the United States' earliest World War I flying "aces," Lloyd Andrews Hamilton. First Lieutenant Hamilton, a native of Troy, New York, was not only an ace for the United States Air Service, a precursor to the United States Air Force, but also was credited with ace status flying for England's Royal Air Force. Hamilton shipped out to England in late 1917, a few months after President Woodrow Wilson had requested a declaration of war against Germany. He trained in England with the 3rd Squadron of the Royal Flying Corps piloting a Sopwith Camel biplane. In April 1918, he recorded his first aerial kill and within a few weeks he had downed five German planes earning the status of a flying ace.

He was soon transferred to the United States Air Service's 17th Aero Squadron to help train new American pilots. In August 1918, he shot down three enemy aircraft and two observation balloons earning his second ace status. On August 13, Hamilton led a daring raid on a German Aerodrome near Varssenaere, Belgium, in which he dropped four bombs from his plane destroying two hangars. He made repeated passes along the airfield, flying as low as 20 feet, destroying two aircraft on the ground and strafing the officers' quarters of the German flyers. For this "extraordinary heroism," Hamilton was awarded both the Distinguished Service Cross and the Distinguished Flying Cross.[1] On a mission two weeks later, Hamilton was shot down and killed by ground fire while attacking transports and troops after destroying another observation balloon.

In 1932, the old Marin County/Marin Meadows Airfield in Ignacio was deeded to the United States Army Air Force and was dedicated on May 12, 1935, in memory of Lieutenant Hamilton. The base was originally a bombardment base of the 1st Wing of the Army Air Corps and was utilized for the defense of the western section of the country until 1940. With the approach of World War II, construction began on a large, modern airbase that would support both bomber and fighter aircraft. It was envisioned by its engineer, Captain Howard Nurse, as a planned community that would not only provide an airfield with hangars and maintenance buildings for the aircraft, but also housing, community centers, movie theaters, and shopping centers for the families of airmen

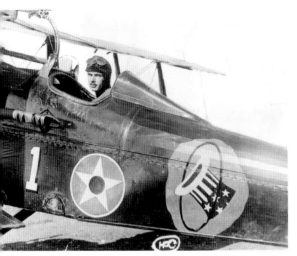

Above left: World War I flying ace Lloyd Andrews Hamilton, 1918.

Above right: Entrance to Hamilton Field Army Air Corps Base, *c.* 1943.

stationed at the base. The development of the base as a planned military community using Spanish Mission architecture represented a growing trend in construction that reflected the topography and history of the region.

The airfield became an important West Coast training base for newly formed fighter groups and played a significant role as an overseas staging area for Air Transport Command's Pacific Division. In the final days of the war, Hamilton Field was the base that received most of the parts of the Hiroshima-bound "Little Boy" atomic bomb flown in from the Manhattan Project complex in New Mexico. From Hamilton, the parts were loaded onto trucks and driven to Hunter's Point Naval Shipyard in San Francisco where the ill-fated USS *Indianapolis* cruiser carried the secret cargo to the island of Tinian in the Pacific.

Hamilton Airfield was decommissioned by the air force in 1975, and over the next twenty years was used by the United States Army, Coast Guard, and Navy for various purposes. From 1980 to 1983 it was also home to an international Refugee Transit Center for the processing of refugees from Vietnam, Cambodia, Laos, Thailand, and Afghanistan. Many of the original Spanish Mission Revival buildings have survived and influenced the architecture and construction of today's modern mixed-use development of the Hamilton Field neighborhood.

Endnotes

Chapter 2

1 Our Documents.gov / Chinese Exclusion Act (1882) *ourdocuments.gov/doc.php*?flash=false&doc=47.
2 Angel Island Immigration Station Foundation, aiisf.org.

Chapter 3

1 "Forty Years of Experience in the Church of Our Savior," *Mill Valley Record*, vol. 34, no. 32, (Mill Valley, Mill Valley Record, 1932) p. 1.

Chapter 5

1 "Holly-Oaks Hotel, Sausalito, Cal.," *Sacramento Bee,* vol. 106, no. 17,370 (Sacramento, James McClatchy Co., 1909) p. 10. Newspapers.com.
2 "Miscellaneous Wanted," *Sausalito News,* vol. 54, no. 19 (Sausalito, John M. Harlan, 1939) p. 2

Chapter 6

1 Stafford, Matthew, Marin County Genealogy/Tiburon/Belvedere: Railroads and Codfish, sfgenealogy.org/marin/ourtowns/ot_t.htm.

Chapter 8

1 Marin Community Development Agency/Analysis of Impediments to Fair Housing Choice January 2020, marincounty.org/-/media/files/departments/cd/housing/fair-housing/2020-ai/2020ai_english.pdf?la=en.
2 Thompson, J., Sr., Golden Gate Village Residents Council/We Came to Stay: Marinship and Marin City, ggvrc.org/ewExternalFiles/Marinship_Marin%20City_75%20Years.pdf.
3 Harper, A., FoundSF/Marinship to Marin City: How a Shipyard Built a City, foundsf.org/index.php?title=Marinship_to_Marin_City:_How_a_Shipyard_Built_a_City.

Chapter 11

1 "Jean Escalle Dead," *Sausalito News,* vol. 35, no. 47 (Sausalito, W.J. Boyd, 1920) p. 1.

Chapter 12

1 Jessup, Harley, "Kent Woodlands: An Interview with Nancy Kent Danielson," *Eden: Journal of the California Garden & Landscape History Society,* vol. 18, no. 1 (Los Angeles, California Garden & Landscape History Society, 2015) pp. 12-13.

Chapter 13

1 "Kentfield Plans May Day Festival," *San Francisco Call,* vol. 105 no. 125 (San Francisco, John D. Spreckels, 1909) p. 39.
2 "The Kentfield Stadium," *The Marin Journal,* vol. 50, no. 18 (San Rafael, The Olmstead Co., 1909) p. 1.
3 "Something More About the Tamalpais Center," *Unity,* vol. 64, no. 12 (Chicago, Unity Publishing Company, 1909) p. 598.

Chapter 14

1 Boussy Henri M., Sliney, Edgar, Mill Valley Historical Society/History of Early Mill Valley, mvhistory.org/history-of/history-of-early-mill-valley/.

Chapter 15

1 *Walking Tours of Historic Larkspur* (Larkspur, Larkspur Heritage Committee, 1976) p. 6.
2 "Dance Under the Stars in the Larkspur Rose Bowl," *Sausalito News,* vol. 60, no. 15 (Sausalito, John Harlan, 1945) p. 2.

Chapter 16

1 Corte Madera Memories/Cows, Horses & Racetracks in Corte Madera, cortemaderamemories.org/racetracks-in-corte-madera.html.
2 "Dairy Hand Was Gored by Bull," *Petaluma Argus-Courier,* vol. 4, no. 74 (Petaluma, The Olmstead Company, 1931) p. 3.

Chapter 17

1 Betten, H. L., "Rod & Gun," *San Francisco Examiner,* vol. 179, no. 8 (San Francisco, Hearst Publications. Inc. 1943) p. 22.
2 "Greenbrae Rod & Gun Club Holds Dance," *Sausalito News,* vol. 73, no. 11 (Sausalito, John M. Harlan, 1959) p. 1.

Chapter 18

1 Coy, J., *San Anselmo* (Charleston, Arcadia Publishing, 2013) p. 7.
2 San Anselmo Historical Museum/Chronological History, sananselmohistory.org/brief-history/chronological-history/.

Chapter 19

1 Dollar, R., *The Memoirs of Robert Dollar* (San Francisco, Robert Dollar Company/Press of Knight-Counihan, 1928) p. 226.

Chapter 20

1 Catholic San Francisco/First San Francisco Archbishop was a Dominican, catholic-sf.org/news/first-san-francisco-archbishop-was-a-dominican.

Chapter 21

1 "Pastori's Near Fairfax: The Ideal Place," *The San Francisco Call,* vol. 110, no. 31 (San Francisco, John D. Spreckles, 1911) p. 10.
2 "Fireman's Banquet Brilliant Event," *The Marin Journal,* vol.53, no. 7 (San Rafael, The Olmstead Co., 1913) p. 8.
3 *Pastori's Hotel and Restaurant, Fairfax, Marin County, Calif,* Postcard, Postmarked from San Francisco, Nov. 11, 1914.

Chapter 22

1 "Witnesses Tell of the Midnight Orgies and Drunken Revels of Baron von Schroeder and His Roystering Companions at the Clubhouse of the Hotel Rafael," *San Francisco Call,* vol. 89, no. 19 (San Francisco, John D. Spreckles, 1900) p. 1.
2 "Baron's Debt Paid," *San Luis Obispo Tribune,* vol. 61, no. 1 (San Luis Obispo, Benjamin Brooks, 1919) p. 1.
3 "Proves That He Fired the Famous Hotel Rafael," *Petaluma Argus-Courier,* vol. 1 no. 31 (Petaluma, Olmstead Co., 1928) p. 3.
4 *Ibid.*

Chapter 23

1 "San Rafael Races," *Sausalito News*, vol. 12, no. 32 (San Rafael, Sausalito News, 1896) p. 3.
2 "Great Wheel Meet," *Marin Journal,* vol. 36, no. 25 (San Rafael, S. F. Barstow, 1896) p. 3.
3 "Bicycle Parade," *Marin Journal,* vol. 39, no. 16 (San Rafael, The Olmstead Co., 1899) p. 3.
4 National Women's History Museum/Pedaling the Path to Freedom: American Women on Bicycles, womenshistory.org/
 articles/pedaling-path-freedom.

Chapter 24

1 "Tamalpais Academy," *Marin Journal*, vol. 17, no. 37 (San Rafael, S.F. Barstow, 1877) p. 2.
2 "Tamalpais Hotel," *Marin Journal*, vol. 12, no. 26 (San Rafael, Jerome A. Barney, 1872) p. 2.
3 "Mt. Tamalpais Academy," *Daily Record Union*, vol. 80, no. 5 (Sacramento, Sacramento Publishing Company, 1890) p. 4.
4 "Popular Mt. Tamalpais Military Academy", *Marin County Tocsin*, vol. 34, no. 38 (San Rafael, The Tocsin Publishing
 Co., 1911) p. 4.

Chapter 25

1 "China Camp," *Daily Independent Journal*, vol. 92, no. 45 (San Rafael, California Newspapers, Inc. 1952) p. L3.

Chapter 26

1 "Joe Gans Counted Out By Death After Brave Fight," *San Francisco Call*, vol. 108, no. 72 (San Francisco, John D.
 Spreckles, 1910) p. 11.
2 "Joe Gans Counted Out By Death After Brave Fight," *op. cit.* p. 11.
3 "Joe Gans Counted Out By Death After Brave Fight," *op. cit.* p. 11.
4 Aycock, C., Scott, M., The Goldfield Historical Society / Joe Gans (Joseph Saifus Butts) The Old Master November 25,
 1874: August 10, 1910, goldfieldhistoricalsociety.com/featured-story JoeGans.html.
5 "Young Corbett at San Rafael," *Marin Journal*, vol. 45, no. 44 (San Rafael, Olmstead Co., 1905) p. 4.

Chapter 27

1 Harris, M., "Big House Boomerang," *Prison Stories,* vol. 2, no. 1 (New York, Good Story Magazine Comp, 1931) p. 60.
2 "Sarah Bernhardt at San Quentin," *San Francisco Call,* vol. 113, no. 80 (San Francisco, W.W. Chapin, 1913) p. 7.
3 "Bernhardt Cheers San Quentin Prison," *San Francisco Call*, vol. 113, no. 85 (San Francisco, W. W. Chapin, 1913) p. 57.
4 *Ibid*.

Chapter 28

1 Leonard, J. P., *Santa Cruz Evening News,* vol. 15, no. 72 (Santa Cruz, Devlin, E. J., Judah, Jr., H. R., 1915) p. 2.

Chapter 29

1 "Baths are Opened," *San Anselmo Herald*, vol. 6, no. 3 (San Anselmo, J.D. Dean, 1915) p. 1.
2 "Eleanor Garatti is Star in Swim Meet," *Sausalito News*, vol. 43, no. 37 (Sausalito, Harry Elliott, 1927) p. 8.

Chapter 30

1 "Puzzle What Became of the Stew," *Marin County Tocsin*, vol. 38 no. 5 (San Rafael, Tocsin Publishing Company, 1914)
 p. 4.
2 "They Made Their Own Entertainment," *Daily Independent Journal*, vol. 103, no. 67 (San Rafael, California
 Newspapers, Inc. 1963) pp. 22 -23.

Chapter 31

1 Sleepy Hollow Homeowner's Association/The History of Sleepy Hollow, shha.org/page-18131.
2 Black, A., *Atlas Obscura*/Hotaling Whiskey Warehouse, atlasobscura.com/places/hotaling-whiskey-warehouse.

Chapter 32

1 "Trustees Divided on Liquor License," *San Anselmo Herald*, vol. 2, no. 20 (San Anselmo. The Olmstead Co., 1913) p. 2.
2 *Ibid*.

Chapter 33

1 Olds, E. F., *Women of the Four Winds* (Boston, Houghton Mifflin, 1985) p. 237.
2 Olds, *op. cit.* p. 286.
3 Boyd, L. A., *Polish Countrysides* (New York, American Geographical Society, 1937) p. 1.
4 *Ibid*. p. 5.
5 Nelson, F. E., University of Wisconsin, Department of Geography/The World's Most Enterprising Woman Explorer: The Louise Arner Boyd Arctic Expeditions of the American Geographical Society, geography.wisc.edu/lectures. php?s=f&y=2010.

Chapter 34

1 "Jacob Albert Builds San Rafael Theater," *Napa Valley Register*, vol. 113, no. 30 (Napa, Francis, G. M., Francis, G. H. 1928) p. 1.

Chapter 35

1 "Roping Club Plans Rodeo, Queen, Too," *Daily Independent Journal*, vol. 94, no. 81 (San Rafael, Roy A. Brown, 1950) p. 22.

Chapter 36

1 King, L. A., "36 Games Hero Williams Dies," *San Francisco Examiner* (San Francisco, The Hearst Corporation, June 26, 1993) p. C-2.

Chapter 37

1 "Summit House," *Marin Journal*, vol. 32, no. 12 (San Rafael, W.B. Winn, 1892) p. 2.

Chapter 38

1 Ptak, E., *Marin's Mountain Play: 100 Years of Theater on Mount Tamalpais* (San Rafael, Mountain Play Association, 2013)
2 Hanrahan, M., Mill Valley Patch/The Mountain Play Celebrates Its 100th Birthday, patch.com/california/millvalley/the-mountain-play-celebrates-its-100th-birthday.
3 Mountain Play/We've Come A Long Way…Building on Decades of Tradition, www.mountainplay.org/about-us/history/.

Chapter 39

1 "Mt. Tamalpais Ridgecrest Boulevard," *Sausalito News*, vol. 40, no. 37 (Sausalito, Harry Elliot, 1925) p. 1.
2 "Ridgecrest Luncheon at Hotel Rafael," *Marin Journal*, vol. 61, no. 25, (San Rafael, E.L. Kynoch, 1922) p. 1.

3 "Marin County is Motoring Paradise," *The Healdsburg Tribune*, vol. 8, no. 6 (Healdsburg, Earle Adams, 1926) p. 2.
4 "Mt. Tamalpais Ridgecrest Boulevard," *Sausalito News,* vol. 40 no. 37 (Sausalito, Harry Elliot, 1925) p. 1.

Chapter 40

1 The Annual Dipsea Race/The History of the Women's Dipsea Hike, dipsea.org/news/2018-02-11-womenshikehistory. php.
2 Spitz, Barry, "Dipsea: 80 years later, Chirone victory still felt," *Marin Independent Journal*, E-Edition, marinij. com/2017/05/25/dipsea-80-years-later-chirones-victory-still-felt/.

Chapter 41

1 Revere, J. W., "Chapter XX," *Keel and Saddle* (Boston, James R. Osgood, and Co., 1872) p. 183.
2 *Ibid*.
3 *Ibid*. pp. 184–185.
4 "Nelson's," *San Francisco Chronicle* (San Francisco, The Chronicle Publishing Co., 1916) p. 4.

Chapter 42

1 Colletta, Find-a-Grave/Samuel Penfield Taylor, findagrave.com/user/profile/47089656.

2 "Resume of San Francisco News," *Sacramento Daily Union*, vol. 12, no. 1775 (Sacramento, James Anthony & Co., 1856) p. 1.

Chapter 43

1 "Anglers for Wily Trout Enjoy Splendid Sport on Opening Day," *San Francisco Call,* vol. 91, no. 123 (San Francisco, John D. Spreckles, 1902) p. 4.
2 Livingston, D., Marin Fire History Project/"A Place Called Tocaloma," marinfirehistory.org/1916-tocaloma-hotel-fire.html.

Chapter 44

1 "Inverness is 125," *Under the Gables*, vol. 19, no. 1 (Inverness, Jack Mason Museum, 2014) p. 4.

Chapter 45

1 "The Country Club," *San Francisco Chronicle*, vol. 58, no. 105 (San Francisco, M.H. DeYoung, 1893) p. 9.
2 *Ibid.*
3 *Ibid*

Chapter 46

1 "Tomales Hotel," *Sonoma County Journal*, vol. 3, no. 11 (Petaluma, Henry L. Weston, 1857) p. 3.
2 "Tomales," *Marin County Journal,* vol. 27, no. 12 (Tomales, S.F. Barstow, 1887) p. 3.
3 *Ibid.*
4 "Tomales a Pile of Ruins," *Napa Weekly Journal*, vol. 23, no. 5 (Napa, J.E. Walden, 1906) p. 3.

Chapter 48

1 Revere, J. W., "Chapter XX," *Keel and Saddle*, (Boston, James R. Osgood, 1872) p. 158.
2 Revere, J. W., *op. cit.*

Chapter 49

1 Marconi Conference Center, marconiconferencecenter.org/conference-center/.
2 "Marconi Buys Station Site," *San Francisco Call*, vol. 113, no. 82 (San Francisco, W.W. Chapin, 1913) p. 4.

Chapter 50

1 Alden, Peter; Heath, Fred, *National Audubon Society: Field Guide to California*. (New York, Alfred A. Knopf, 2008) pp. 15.

Chapter 51

1 United States Coast Guard/Pt. Reyes Lighthouse, history.uscg.mil/Browse-by-Topic/Assets/Land/All/Article/1976532/point-reyes lighthouse/; en.wikipedia.org/wiki/Point_Reyes_Lighthouse.
2 United States Lighthouse Society/Lighthouse Glossary of Terms, uslhs.org/education/glossaries-facts-trivia/lighthouse-glossary-terms.

Chapter 52

1 "Death of James Marshall," *Marin Journal*, vol. 36, no. 35 (San Rafael, S.F. Barstow, 1896) p. 3.
2 "Marshall Items," *Marin Journal*, vol. 14, no. 32 (San Rafael, S.F. Barstow, 1874) p. 3.
3 "Historic Old Hotel Burns Down," *Daily Independent Journal*, vol. 111, no. 199 (San Rafael, California Newspapers, Inc, 1971) p. 1.

Chapter 53

1 "New Sir Francis Drake Highway Ceremonies of Dedication," *Mill Valley Record*, vol. 31, no. 40 (Mill Valley, Mill Valley Record, 1929) p. 2.

Chapter 54

1 Phone interview with Peter Phibbs, September 24, 2020.
2 Phone interview with Allan Reeves, September 26, 2020.
3 Phibbs, *op. cit.*
4 Luscombe, R., *The Guardian*/California surfer's "measly punch" fends off great white shark attack, theguardian.com/us-news/2021/oct/11/california-surfer-punched-great-white-shark-attack.

Chapter 55

1 Fusek, M., *Novato Patch*/Honoring Novato's Generations: Meet Parade Grand Marshal Herb Rowland, patch.com/california/novato/honoring-novatos-generations-meet-parade-grand-marshal-herb-rowland.
2 *Ibid.*

Chapter 56

1 Yarish, A., "Novato Comes to Life," *The Novato Historian,* vol. 37. No. 2 (Novato, Novato Historical Guild, 2013) p. F1.
2 Yarish, A, *op. cit.* p. F2.

Chapter 57

1 "Two Charges Eliminated in Novato 'Mau Mau' Brawl," *Daily Independent Journal,* vol. 98, no. 295 (San Rafael, Daily Independent Journal, 1959) p. 8.
2 "Blackpoint Inn," *Marin Independent Journal,* vol. 114, no. 274 (San Rafael, Marin Independent Journal, 1975) p. 17.

Chapter 58

1 Hall of Valor Project/Lloyd Andrews Hamilton, valor.militarytimes.com/hero/15951.

Selected Readings and Additional Resources

Selected Readings

Boyd, L. A., *Polish Countrysides*, (New York, American Geographical Society, 1937)

Clapp, O., *San Geronimo Valley*, (Charleston, Arcadia Publishing, 2019)

Coy, Judy, *San Anselmo*, (Charleston, Arcadia Publishing, 2013)

Dollar, R., *The Memoirs of Robert Dollar*, p. 226 (San Francisco, Robert Dollar Company / Press of Knight-Counihan, 1928)

Fanning, B., *The Tiburon Peninsula* (Charleston, Arcadia Publishing, 2006)

Heitkamp, H., Cunningham, R., *Larkspur Past and Present: A History and Walking Guide* (United States of America, Larkspur Heritage Preservation Board, 2010)

Hines, L., 'The Pacheco Ranch: A Brief History', *The Novato Historian*, vol. 23 no. 1, p. 1-2 (Novato, Novato Historical Guild, Inc., 1999)

Livingston, D. S., *Ranching on the Point Reyes Peninsula*, (Point Reyes Station, National Park Service, 1993)

Mason, J., *Jack Mason's Olema, Dear Valley* (Inverness, North Shore Books, 1976)

Olds, E. F., *Women of the Four Winds* (Boston, Houghton Mifflin, 1985)

Ptak, E., *Marin's Mountain Play: 100 Years of Theater on Mount Tamalpais* (San Rafael, Mountain Play Association, 2013)

Revere, J. W., 'XX' in *Keel and Saddle*, (Boston, James R. Osgood, 1872)

Sagar, W., Sagar, B., *Fairfax* (San Francisco, Arcadia Publishing, 2005)

Spitz, B., *Marin A History*, (San Anselmo, Portrero Meadow Publishing, 2006)

Spitz, B., *Mill Valley: The Early Years* (Mill Valley, Potrero Meadow Publishing Co., 1997)

Palmquist, P. E., Kailbourn, T. R., *Pioneer Photographers of the Far West: A Biographical Dictionary, 1840–1865*, p. 153 (Stanford, CA, Stanford University Press, 2000)

Tibbetts, J. C., Welsh, J. M., *American Classic Screen Features* (Lanham, MD, Scarecrow Press, 2010)

Tracy, J., *Sausalito: Moments in Time*, (Sausalito, Windgate Press, 1983)

Yarish, A., 'Novato Comes to Life', *The Novato Historian*, vol. 37. No. 2, pp. F1-F4 (Novato, Novato Historical Guild, 2013)

Additional Resources

Ancestry, ancestry.com

Angel Island Conservancy/Angel Island Timeline, angelisland.org/wp-content/uploads/2010/04/Angel-Island-Timeline.pdf

Anne T. Kent California Room, Marin County Free Library/Frank Morrison Pixley's Owl's Wood: An Oasis in

Corte Madera, medium.com/anne-t-kent-california-room-community-newsletter/frank-morrison-pixleys-owl-s-wood-an-oasis-in-corte-madera-e7d233ff08aa

Atchley, T., Redlands Daily Facts/Prospect Park History, Part 3, redlandsdailyfacts.com/2009/04/18/prospect-park-history-part-3/

Bassett, D., Murray, J., City of Mill Valley/A Brief History of Mill Valley, cityofmillvalley.org/community/about/history.htm

Baywood Equestrian Center/Circle V History, baywoodequestriancenter.com/history

California Digital Newspaper Collection, cdnc.ucr.edu

Corte Madera Memories/Cows on the Marsh, cortemaderamemories.org/uploads/6/3/5/4/63546529/meadowsweet_-_chapter_31.pdf

Corte Madera Memories/Cows Horses and Racetracks in Corte Madera, cortemaderamemories.org/racetracks-in-corte-madera.html

Dougherty, P. M., Dominican University of California/Goemaere: Mary of the Cross, scholar.dominican.edu/cgi/viewcontent.cgi?article=1133&context=books

Fish, P., *Marin Magazine* (Digital Edition)/William Kent's Marin, marinmagazine.com/feature-story/william-kents-marin/

Friends of China Camp/History of China Camp, friendsofchinacamp.org/about-china-camp/history/

Harper, A., FoundSF/Marinship to Marin City: How a Shipyard Built a City, foundsf.org/index.php?title=Marinship_to_Marin_City:_How_a_Shipyard_Built_a_City

Harris, A., Black Past/Marin City (1942-), blackpast.org/african-american-history/marin-city-california-1942/

Harrison, R. L., Anne T. Kent California Room, Marin County Free Library/A 140-Year-Old Marin Road, medium.com/anne-t-kent-california-room-community-newsletter/a-140-year-old-marin-road-acebf4069f85

La Belle, Audre, Sleepy Hollow Homeowners Association/The History of Sleepy Hollow, shha.org/page-18131

Meral, J., Pt. Reyes Light/A look back at the creation of the Point Reyes National Seashore, ptreyeslight.com/features/look-back-creation-point-reyes-national-seashore/

Livingston, D., Marin Fire History Project/"A Place Called Tocaloma," marinfirehistory.org/1916-tocaloma-hotel-fire.html

Marconi Conference Center/Marconi State Historic Park Through Time, marconiconferencecenter.org/marconis-history/

National Park Service/William Kent: Conservationist and Anti-Immigrant Politiciannps.gov/articles/williamkent.htm

Novato Historical Guild/Timeline Hamilton Field, novatohistory.org/timeline-hamilton-field/

Newspapers.com, newspapers.com

Parks, G., El Camino Theater/cinematreasures.org, cinematreasures.org/theaters/13629

Perry, C., Montecito Area Resident's Association/Where Salvation Army Stands Today, montecitoresidents.com/single-post/2014/08/01/Roberts-Dairy-Where-Salvation-Army-Stands-Today

Read, M., Novato Historical Society/Pages From the Past: Hiroshima A-Bombs Went Through Novato, marinlocalnews.com/pages-from-the-past-hiroshima-a-bombs-went-through-novato/

Revitti, F., Southern Sonoma Country Life/Marinscapes Fundraiser at Historic Escalle Winery: A Time Portal into The Past, southernsonomacountrylife.com/blogs/2015/06/marinscapes-fundraiser-at-historic-escalle-winery-a-time-portal-into-the-past-.html

Sleepy Hollow Homeowner's Association/The History of Sleepy Hollow, shha.org/page-18131

St. Stephen's Church/St Stephen's Episcopal Church History, silo.tips_st-stephen-s-episcopal-church-history-belvedere-california-st-stephen-s-episcopal-church.pdf

Stafford, M., Marin County Geneology/Tiburon Belvedere: Railroads and Codfish, sfgenealogy.org/marin/ourtowns/ot_t.htm

The Annual Dipsea Race, dipsea.org

The History of the Women's Dipsea Hike, dipsea.org/news/2018-02-11-womenshikehistory.php

The Men of the Second Oxford Detachment/Lloyd Andrew Hamilton, parr-hooper.cmsmcq.com/2OD/the-biographies/lloyd-andrews-hamilton/

Thompson, L., Anne T. Kent California Room, Marin County Free Library/Beatriz Michelena: Pioneer Latina Film Star, medium.com/anne-t-kent-california-room-community-newsletter/beatriz-michelena-pioneer-latina-film-star-fb0450080d9cThompson

Founded in 1935, the Marin History Museum celebrates the traditions, innovation, and creativity of the people of Marin County. Eighty-six years later, we continue to be committed to our mission and the stewardship of our vast collections. The Museum houses over 25,000 artifacts and over 200,000 photographic images. The Research Library offers access to primary source materials by appointment. Through creative exhibits and educational programs, MHM inspires honor for the past, an understanding of the present and imagination of the future. We are thrilled to be back at the Boyd Gate House in San Rafael. Walking into this Gothic Revival-Style house transports you to a different time. The intricate molding, ornamental chandeliers, ornate fireplaces and winding staircases that have been in place for over a century tell a story of how we lived: what life was like in the late 1800s. We are honored to share local history in this Victorian treasure. marinhistory.org/

All images included in *Moments in Marin History* are available for purchase by calling 415-382-1182 or by email at info@marinhistory.org.

Index